Watercolor Skills
Workbook

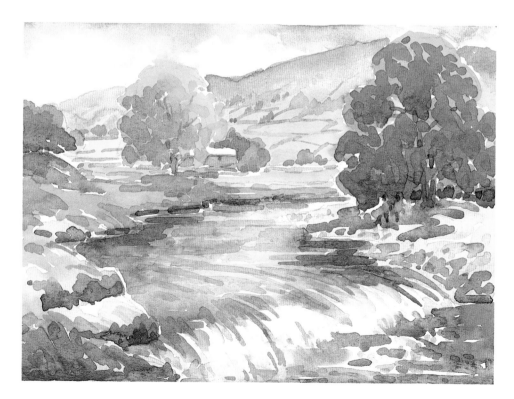

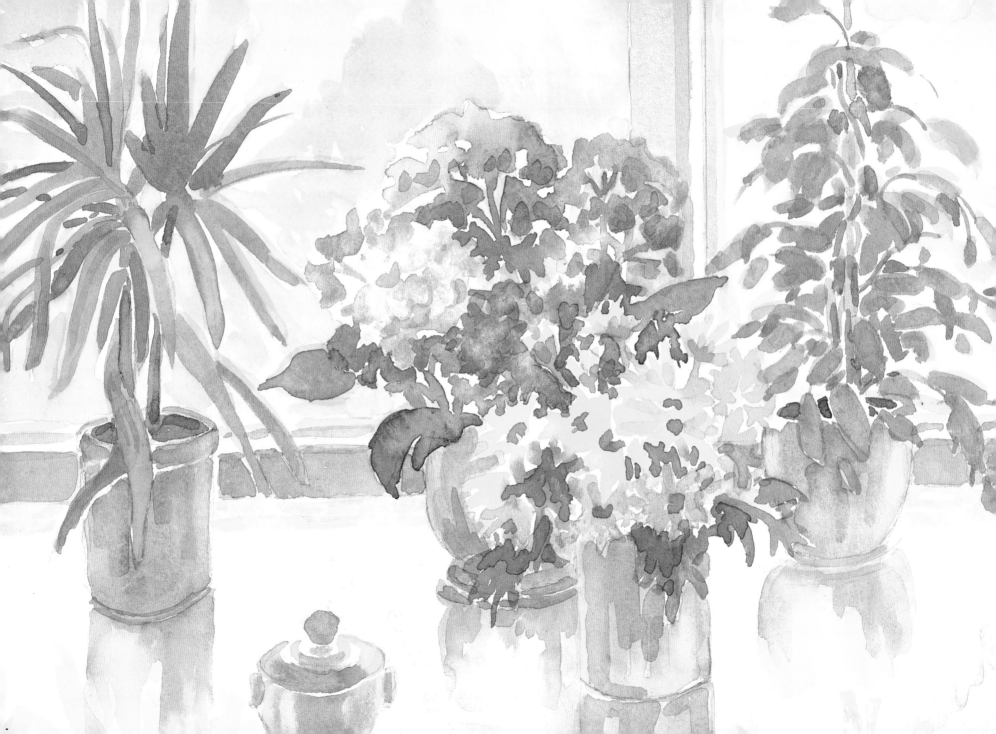

Anne Elsworth

Watercolor Skills Workbook

DEVELOP YOUR ARTISTIC SKILLS IN TEN EASY LESSONS

NORTH LIGHT BOOKS

Cincinnati, Ohio

Page 2 PLANTS AT A WINDOW

A DAVID & CHARLES BOOK

First published in North America
in 2001 by North Light Books
an imprint of F&W Publications, Inc.
1507 Dana Avenue, Cincinnati, OH 45207
(800) 289-0963

First published in the UK in 2001
Copyright © Anne Elsworth 2001

ISBN 1-58180-203-X

Printed in Singapore by KHL
for David & Charles
Brunel House Newton Abbot Devon

Publishing Manager Miranda Spicer
Commissioning Editor Anna Watson
Art Editor Diana Dummett
Desk Editor Freya Dangerfield
Designer Maria Bowers

Thanks to St Cuthbert's Mill and The Art Shop,
Ilkley for help with papers and materials.

Contents

Introduction

When a learner painter reaches a certain stage of proficiency, he or she may find it difficult to know how to make further progress. The dilemma lies in having evolved ways of working which offer a measure of success, and yet fail to satisfy fully. Perhaps it is in the nature of creativity never to be completely happy with one's efforts – certainly it seems to me that as I progress I am constantly moving the goalposts. However, this is not the whole story. Many students speak to me of an initial surge of rapid progress followed by months, or even years, of frustration and disappointment.

Surprisingly the solution to this common dilemma lies in experimentation. Let me explain. By trying new subjects and new approaches the student is obliged to use new ways of working, and is thus precipitated willy-nilly into learning and progress. It is perhaps easier to express this negatively by saying that when we always work in the same way we should not be surprised that things always turn out much the same.

In my previous book, the *Watercolour Workbook*, my aim was to lead the beginner painter through the essential techniques of the medium using a variety of subjects. The projects were designed to focus on media and method. Although I did stress the need for regular drawing practice and offer some guidelines for composition, colour mixing and three-dimensional illusion, these areas were not explored in any depth. This book covers these and many more aspects of art and, since practical experience is essential to progress, I hope you will not merely read these pages, but will also work through the many projects offered.

The artistic journey

It is true that every aspiring artist progresses in a uniquely individual manner influenced along the way by other painters, by teachers, by their own experiments and experiences with paint, and indeed, by their own life experience. Equally it is true that all will pass through similar phases of development which can be identified as 'stages' on the artistic journey. These stages are not clear cut and distinctly separate, but tend to overlap. Nevertheless it is worthwhile trying to recognize what stage you yourself have reached in order to understand how you may move forward.

Stage one

The first stage could be called 'the search for realism'. It involves learning to observe accurately, and acquiring the skills to record convincingly what you have seen. Like many other beginners, you may find yourself complaining that 'my trees don't look real' or 'my buildings are falling down'. This is where some regular observational drawing practice is needed. You will discover techniques that will enable drawing in perspective, and you need to pay attention, too, to the shape and relative size and position of objects. In addition there is much you must learn about materials and equipment, colour mixing, and the techniques of putting paint on to paper. Gradually you will acquire a new language – words such as line, shape, tone, texture and colour – and little by little you will come to see and to think in these terms.

No sooner have you gained some mastery of these things, however, than you begin to realize that there is actually more to successful painting than the ability to copy from nature – and thus you will, imperceptibly, then move on to the next stage.

Stage two

The second stage might be called 'the search for beautiful images'. It is not that the need to observe and record faithfully is no longer important, but that aesthetic considerations begin to assume an equal or even greater importance. Gradually you become aware of the need to bring some sense of order and harmony to your work. Coupled with this awareness the realization that much art is concerned with illusion may be a real eye-opener, encouraging you to interpret more freely, or to simplify in order to achieve a particular effect. You can now appreciate that previously nebulous concept 'artistic license' as an aid to creating images which are both convincing representations of reality and also a pleasure to the eye. During this stage, it is likely that you will begin to appreciate the intrinsic beauty of paint itself – the richness of oils, the transparency and unpredictable effects of watercolour, the simultaneous paint-and-draw possibilities of pastels, and so on. At the same time you may develop a growing interest in the possibilities of different media, and a willingness to try different subject matter – and thus you might find that, for you, the third stage has already begun.

Stage three

I call this stage 'the search for the artist within' but find it the hardest to define. Certainly the effort to create coherent and beautiful images in a way which celebrates the chosen medium continues. What is different now is that you gradually discover your own particular passions and begin to develop what is often called a 'personal vision'. Paradoxically it seems that no sooner has a student developed an open-minded attitude to media, methods and approaches as well as to subject matter, than he or she becomes aware of a sort of tunnel vision, a wish to concentrate on particular interests and enthusiasms – one could even say obsessions. Although these particular passions may wax and wane, it seems to me that this stage of the journey is continuous and unending.

Using this book

While the *Watercolour Workbook* is primarily concerned with the techniques of the watercolour medium, the emphasis in this book is on concerns which are common to all media. It is divided into three sections, equating to the three stages described above.

The first section is concerned with realistic representation and offers projects to help you practise your ability to observe accurately and record faithfully some relatively simple subjects. The emphasis is on drawing, colour mixing, and the creation of three-dimensional illusion.

The second section is devoted to aesthetic considerations. There are suggestions for ways to improve your intuitive judgement, and for new approaches to creating pleasing compositions and beautiful colour schemes. In addition a number of the projects are designed to celebrate the beauty of paint itself.

The third section aims to encourage experimentation of every kind so that you may be enabled to discover your own unique artistic vision.

Finally, for easy reference a list of all the projects suggested in the book is provided at the back, giving brief descriptions of their content and purpose, as well as the relevant page numbers.

Enjoying your journey

It may be that you have only recently set out on your own artistic journey, or you may already have been on the road many years. As with many journeys, there is so much to be enjoyed along the way that arriving at some predetermined destination no longer seems so important.

Materials and equipment

Some readers of this book will be new to watercolour painting, while others may have some experience and therefore have colours, brushes and equipment with which they are already familiar. The following is a list of the materials which I have used in the paintings in this book and which you will need in order to complete the projects. (For more detailed information, refer to my earlier book, *Watercolour Workbook*.)

Watercolour paints

In the following lists I describe the colour first, and then give some of the names under which that colour is marketed. I hope that this will enable you to make comparisons with colours you already have, and to decide which ones you need to buy.

Basic palette
- Cool yellow with a green bias – 'lemon' (*Winsor lemon, lemon yellow, lemon yellow hue*).
- Warm yellow with an orange bias – 'butter' (*cadmium yellow*).
- Warm red with an orange bias – 'flame' (*cadmium red, cadmium red pale*).
- Cool red with a violet bias – 'wine' (*alizarin crimson, permanent alizarin crimson*).
- Warm blue with a violet bias – 'cornflower' (*ultramarine, French ultramarine*).
- Cool blue with a green bias – 'turquoise' (*Winsor blue, green shade; monestial or phthalo blue; intense blue*).

Extra colours for flower painters
- True or rose red (*permanent rose*).
- Magenta (*quinacridone magenta, permanent magenta*).
- Violet (*permanent mauve, purple or Winsor violet*).

Optional extras for flower painters
- True yellow (*Winsor yellow, aureolin*).
- True orange (*cadmium orange*).
- True blue (*cobalt*).
- Yellow-green (*sap, permanent sap*).
- Blue-green (*viridian; Winsor green, blue shade*).

Extra/optional colours for landscape painters
- True yellow (*Winsor yellow, aureolin*).
- True or rose red (*permanent rose*).
- Impure yellow – 'mustard' (*raw sienna*).
- Impure red – 'brick/rust' (*light red*).
- Impure red – 'foxy brown' (*burnt sienna*).
- Greens as for flower painter's palette.

Additional media

Occasional use has been made of media which can be combined with watercolour paint, and in the final section of the book other water-based media are included.

Most aspiring watercolourists are resistant to the idea of working in any other medium. This is understandable: given the limited amount of time available to most leisure painters it would seem logical to specialize. However, no course would be complete without at least some reference to those media which are traditionally associated with watercolour. Basic starter sets are available for any of the following materials, and individual colours can be added later.

Ink

First among these optional extras is ink, sometimes used to enhance a painted image and sometimes used in the form of line and monochrome wash (different tints of the same colour). Today, inks are marketed in ready-loaded pens as well as

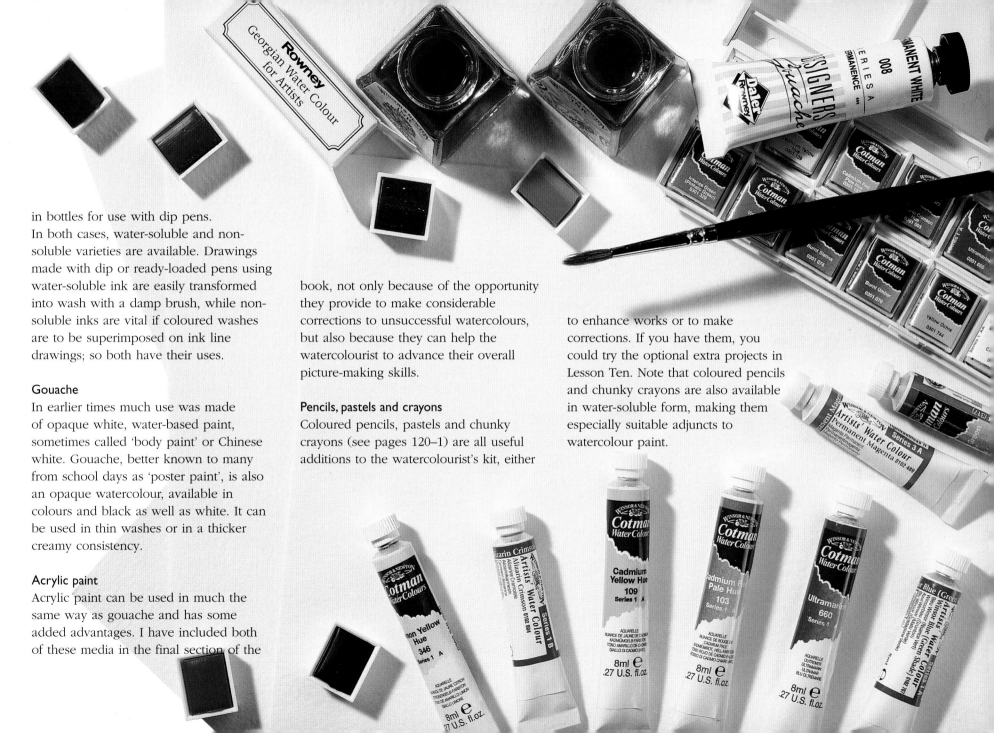

in bottles for use with dip pens.
In both cases, water-soluble and non-soluble varieties are available. Drawings made with dip or ready-loaded pens using water-soluble ink are easily transformed into wash with a damp brush, while non-soluble inks are vital if coloured washes are to be superimposed on ink line drawings; so both have their uses.

Gouache

In earlier times much use was made of opaque white, water-based paint, sometimes called 'body paint' or Chinese white. Gouache, better known to many from school days as 'poster paint', is also an opaque watercolour, available in colours and black as well as white. It can be used in thin washes or in a thicker creamy consistency.

Acrylic paint

Acrylic paint can be used in much the same way as gouache and has some added advantages. I have included both of these media in the final section of the

book, not only because of the opportunity they provide to make considerable corrections to unsuccessful watercolours, but also because they can help the watercolourist to advance their overall picture-making skills.

Pencils, pastels and crayons

Coloured pencils, pastels and chunky crayons (see pages 120–1) are all useful additions to the watercolourist's kit, either

to enhance works or to make corrections. If you have them, you could try the optional extra projects in Lesson Ten. Note that coloured pencils and chunky crayons are also available in water-soluble form, making them especially suitable adjuncts to watercolour paint.

Essential extras

In order to complete all the projects in this book you will need to add the following to your watercolour kit:

- Pencil case containing assorted graphite pencils (HB, B, 4B, 6B) for general drawing, a pencil sharpener or penknife, and a kneadable putty rubber which I find does least damage to watercolour paper.
- Two ready-loaded drawing pens, one soluble and one non-soluble, sometimes called 'pigment liners'. The thickness of the nibs is not critical – I suggest 0.5 or 0.7 – but permanence to light is essential.
- Acrylic paints for the two projects at the end of the book. You will find all you need to know about them, and the materials to buy, on pages 122–4.

Brushes

Most of my brushes are a mix of synthetic and sable hair, and these combine the water-holding properties of sable with the durability of synthetic fibres. Several manufacturers have a wide range of such brushes.

Essential brushes

For the lessons in this book you will need the following brushes:

- Rounds in Nos. 5, 8, 10, 12 and 16.
- 15mm (⅝in) flat.

- Medium mop or wash brush for laying large washes.
- No. 1 rigger for fine details.
- 12mm (½in) acrylic flat for making corrections or lifting out precise shapes. (The hair of acrylic brushes is just a little stiffer than normal watercolour brushes but will not scratch the surface of the paper.)

Additional tools

To create different marks from those produced by a brush, the following can be effective:

Sponge

A sponge is useful for making corrections, and can also be used to create textured areas such as foliage.

Special effects

For various special effects I may use the following from time to time: a wax candle for wax-resist work; clingfilm and/or bubble pack for creating texture; and masking fluid so that I can work freely over 'reserved' or masked areas of white or colour. Masking fluid can be applied with a pen, a brush, or a matchstick.

Papers

For most of the projects I have used a NOT or cold-pressed paper of 425gsm (200lb) weight which is heavy enough not

to need stretching. For very large works involving a lot of water use a 638gsm (300lb) weight paper. Lighter papers are cheaper, of course, but for most purposes papers of 300gsm (140lb) or less should be stretched so they don't crinkle when wet. Where smooth or rough surfaces were more appropriate than medium-textured NOT ones, I have indicated this in the text.

Sketchbook

You will need an A4 ring-bound book of cartridge paper for sketches and studies.

Palette

To ensure that I have a sufficient quantity of the different colour mixes available, I always use a palette with deep mixing areas or 'wells'. Some boxes of pan colours (colours in block form) have good, deep wells, and such a box is useful for outdoor and holiday painting. However, for most purposes I prefer paint in tubes. To mix these, I use a large palette with 15 small wells along the edge and several deep mixing areas. (Please note that for the colour-mixing exercises in Lesson One tubes are essential since they enable a systematic palette layout.)

Essential equipment

To complete the projects in this book, you will need the following equipment:

- Drawing board on which to rest your paper.
- Drawing-board clips or masking tape to secure paper to your board.
- Large jam jar or plastic pot for water.
- Roll of kitchen paper for removing excess moisture from your brush, and for blotting up excess paint.

Additional equipment

You may find the following pieces of equipment useful additions to the standard kit outlined above.

Easel

Strictly speaking this is an optional extra, especially for those who sit down to paint, but I like to stand and to have both hands free so an easel is a must for me. I have a metal field easel which I can use both indoors and out, and which is heavy enough to be stable without breaking my back. I find metal easels much easier to erect than wooden ones, although I realize that this is very much a matter of personal preference.

Folding stool

Whether or not you have an easel, a stool is a useful item for outdoor working, either as something to sit on or to serve as a table for some of your materials.

Bag and baggage

When working outside I have a satchel to hold paints and other essentials, including my sketchbook and pencil case. My easel bag also has a shoulder strap. I carry my sheets of paper fastened to a drawing board in a large polythene bag with handles.

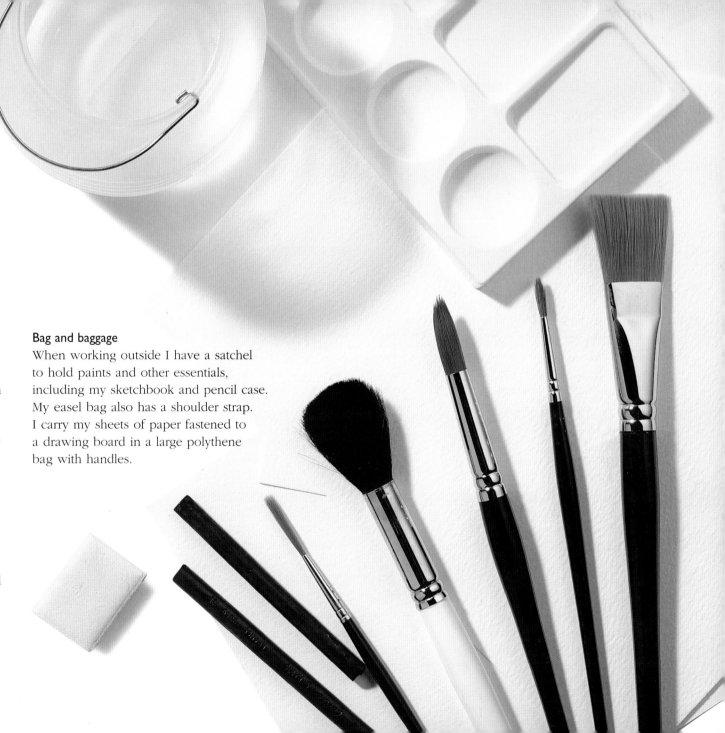

Basic techniques and working methods

The following is a summary of the basic techniques and methods of working referred to in the instructions for the projects. See also the experimental techniques described in Lesson Eight (pages 86–9).

Techniques

Wet-in-wet
Adding or feeding extra water or extra colour into an area of paint before it has dried. It also describes a watercolour painting method (see page 13).

Superimposing
Laying a second layer of colour on top of a previously painted one; this technique is also known as 'wet on dry'. The first layer must be completely dry, and the second layer may be applied as separate brushmarks, or may cover larger areas when it is also known as 'glazing'.

Lifting
Removing small areas of previously painted colour. If the paint is still wet, colour may be lifted using kitchen paper, tissue, blotting paper, a sponge or a damp-dry brush. To lift paint which has dried, dampen with a brush or sponge and immediately dab firmly with kitchen paper to prevent the loosened colour from spreading into adjoining areas.

Hard edge
A clearly defined outline on any area of wash or brushmark. Hard edges can be softened if desired by stroking gently with a damp brush.

Soft edge
A soft, blurred outline on any area of colour or brushmark. Paint applied to damp paper will always be soft-edged. Note: shadows may be hard-edged on one side, but may fade away to a soft edge on another.

Paper dams
My own term, coined to denote narrow gaps of dry white paper used to prevent colours from bleeding together when wet. A hallmark of the direct method (see page 13), they can add light and sparkle to a

▲ WET-IN-WET
Adding extra colour to wet paint causes the colours to bleed softly into each other.

▲ SUPERIMPOSING
Applying extra colour to dry paint produces clearly defined shapes for added tone.

▲ LIFTING
Colour can be lifted out of wet paint to create highlights.

▲ HARD EDGE
Paint applied to dry paper cannot spread and so it has a crisp edge.

▲ SOFT EDGE
Caused when colour is applied to damp paper or paint which makes the colour spread.

▲ PAPER DAMS
Deliberately leaving gaps of dry white paper prevents colours from running into each other.

work. If desired, the effect may be lessened by stroking with a damp brush so that the dry paint softens into the gaps.

Methods of working

While some artists may work for the main part in one of the three methods described below, most of them work in a combination of the three.

The direct method

The process of painting one patch or area at a time, sometimes allowing adjoining areas to run and blend together, and sometimes keeping them apart by means of 'paper dams'. In flower and still life painting it does not matter in what order the areas are painted, but in landscape it is usual to work from the top of the paper to the bottom (which effectively means working from the background to the foreground).

The layer method

The process of painting in a series of wash layers or glazes superimposed one on another, and which gradually build up tone and colour. The first or base wash must be painted around any areas to be 'reserved' as white paper. Subsequent layers may have additional 'windows' to reserve not only the white areas but also selected areas of previous washes. It is essential to allow the first layer of paint to dry completely before superimposing additional layers if undesirable muddy effects are to be avoided. Layers may be uniform in colour and tone; gradated (of varying tone); or variegated (multicoloured).

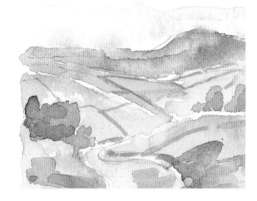

▲ THE LAYER METHOD
This exploits the translucency of the medium, allowing colour and tone to be built up with each new layer.

Tip

To test that a layer of paint is dry, press the back of your forefinger on the painted area and then compare the temperature of that with an unpainted area.

The wet-in-wet method

The process of painting on wet paper. Although the method is difficult to control, it is capable of producing most beautiful effects of diffused light, mist, or rain. When dry, final touches to give definition may be added.

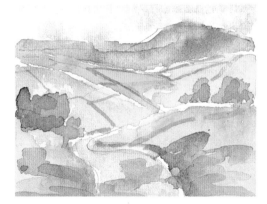

◀ THE DIRECT METHOD
This involves painting one area at a time without necessarily waiting for adjacent areas to dry. 'Paper dams' between different colours will prevent them bleeding into each other.

◀ THE WET-IN-WET METHOD
This exploits the tendency of the medium to spread when applied to a wet surface, so that colours bleed into each other and edges are blurred.

SECTION ONE

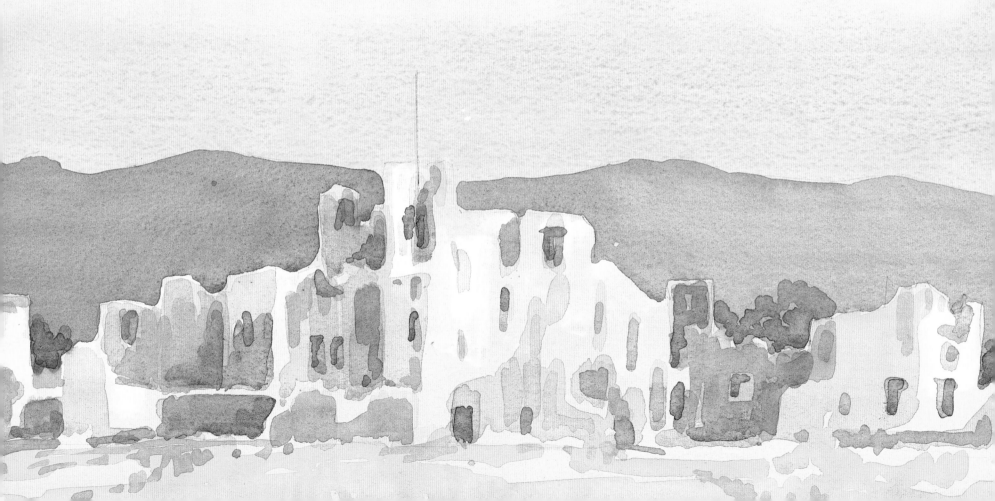

The search for realism

It must be said that this first section of the book is the least exciting. With so many interesting and stimulating painting projects ahead there will be a great temptation to skim through it, or even to go directly to Section Two. Experienced painters could do so with impunity. If you read the aims at the start of each lesson you will know whether you can safely move on. I find that most leisure painters appreciate that there are gaps in their understanding and ability, but find it difficult to identify them precisely. I hope the aims will help you to identify and rectify any such weaknesses in your work.

Less experienced painters should know that the ability to mix colour, to draw accurately, and to create the illusion of both form and space are the essential basic skills of picture making. They underpin all that is to follow, and free

◄ MIDDLEHAM CASTLE

the learner painter to attempt with confidence every kind of subject and every approach to painting.

There are two other incentives to working patiently through Section One. First, I hope to instil, through constant repetition, a professional way of looking and thinking with regard to the formal elements of art. To see objects and think of them in terms of line, shape, tone, texture and colour, rather than as trees, hands, petals and so on, will enable you to move from one subject to another without anything new to learn. In addition, this way of working provides the solutions to all painting problems so that in time you will become independent of writers, teachers and critics, and will achieve control of your own progress.

Second, this section offers the opportunity to practise the techniques used

in watercolour painting, and to this end I have included projects in the direct method (painting one area at a time); the layer method (building up the image in successive layers of washes); and in wet-in-wet techniques. This first section also features a high proportion of still-life subjects because still life is an easier subject than landscape – and thus I hope to build up your confidence slowly but surely.

Conquering colour

Colour is the most accessible aspect of art. Even if the image is unrecognizable and the artist's intention is a mystery to you, you can still respond to the colours and say with confidence that you do or do not like them.

Colour has many roles in painting in addition to the purely aesthetic one. It plays a part in composition: harmonious colours bind together the disparate elements of a work. It is extremely significant in creating the illusion of space, distance and form, and may be used to convey a sense of climate or time of day. Above all, colour can be used to express the artist's feelings and to evoke a response from the viewer.

Primaries, secondaries and tertiaries

Any teacher or demonstrator will tell you that the most frequently asked questions are, 'What colours are you using?' and 'How did you mix that?' Being able to produce whatever subtle shade or tint is required at the drop of a hat is something which professional artists may take for granted, but which seems an almost magical skill to beginner painters. However, it is a facility which can be learnt via a little theory and a little practice, and through a determination to lay out the palette in a logical and systematic way. The following pages set out the theory in easy stages and offer a related project for each stage.

We start with six pigments – two of each of the three primary colours (yellow, red and blue). By combining these primary pigments in specific pairs, we shall produce secondary colours – that is, oranges, violets and greens.

After this we shall discover the possibilities of combining three primary pigments. These mixes are referred to as 'tertiary' colours.

Aims

- To establish a systematic palette layout
- To enable a maximum number of mixes from a limited range of pigments
- To understand the significance of colour wheel theory for practical colour mixing
- To learn a common language of colour
- To understand the different pigment needs of landscape and flower painters, and to learn some useful shortcuts to mixing

Other useful terms

Colour saturation The purity and intensity of colour.

Colour wheel A system of organizing colours.

Complementary colours Two colours directly opposite each other on a colour wheel.

Cool colour Generally blues, and those colours with some blue content.

Earth colours Those derived from natural earth deposits or synthetic iron oxides; like tertiary mixes in appearance.

Impure colours Tertiaries or earth colours.

Neutral colour A tertiary mix, grey or black, with no colour bias. A colour can be rendered more neutral by the addition of its complementary.

Pure colour Primaries and secondaries, either at full strength (saturation) or tinted (paler).

Tint Any colour made paler by the addition of either more water or (in opaque media) white pigment.

True colour A primary or secondary colour without any bias towards another colour; for example, true green is neither yellow-green nor blue-green.

Warm colour Generally yellows and reds and those colours with some red content.

Note For more detailed information about the qualities and characteristics of different pigments than is given in these pages, refer to my *Watercolour Workbook*, or to manufacturer's leaflets, or seek advice from your local retailer.

Exercise:

Laying out a palette

For this you will need six primary colours – lemon yellow, butter yellow, a clear, bright red, wine red, a warm blue and a cool blue (see page 8 for the names under which these colours are marketed).

You will also need a piece of watercolour paper approximately A4 in size, a No. 8 brush, a palette, a pot of water, and a rag or some kitchen paper.

Squeeze out the six primary pigments along the edge of your palette starting with the two yellows – first the cool yellow and then the warm one. Leave a small gap before adding the warm red and then the cool wine red. After another gap complete the line with the warm blue and then the cool one.

Dampen the brush and use it to transfer a little of the lemon yellow to a mixing area and dilute with a small amount of water. Paint the lemon yellow at the top left of the paper. Before it has time to dry, rinse the brush and use it to pull the colour down the paper. This should enable you to see it at full strength (saturation) and also in its paler (tinted) form. Repeat the process for all six

colours, ending with the cool blue at the right-hand side.

In practice it is easy to see the difference between the two yellows and the two reds just by looking at them on the palette, but with blues it is more difficult because of their darkness. The purpose of the exercise is to note the logical progression of the colours, starting with the cool lemon and moving on through a more orangey warm yellow, a warm somewhat orangey red, cooler red, warm blue and finally, cold blue. If the colours were in a circle rather than a straight line on your palette, the cool blue would be next to the lemon yellow. To see what this would look like, bend the paper round so that the left-hand side and the right-hand side are touching.

Remember ...

The order given here is the one in which you must always lay out your palette. Failure to do so will nullify all the colour-mixing lessons which follow.

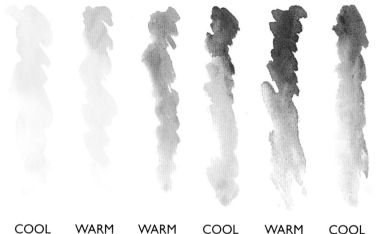

| COOL YELLOW | WARM YELLOW | WARM RED | COOL RED | WARM BLUE | COOL BLUE |

▲ PALETTE LAYOUT
The six colours are arranged in a logical sequence which equates to the order of colours on a colour wheel (left).

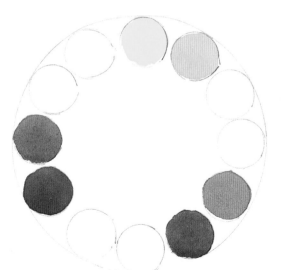

Exercise:

Combining two primaries for the purest secondaries

Using a dinner plate as a template, draw a circle on a piece of watercolour paper with an HB pencil. Add numbers from 1–12 around the outside edge, like the numbers on a clock face ie with number 12 at the top of the circle. Draw 12 discs just inside the circle, using a coin as a template and spacing them as evenly as possible.

Now set out the same six colours as on page 17 around the edge of the dinner plate. Starting with lemon yellow at the 12 o'clock position and ending with the cool blue at 9 o'clock, paint the six colours as shown in Step 1, with gaps of two places between each pair of primaries. The paint should be thin enough to be malleable but thick enough to cover the paper with rich colour.

Next, in a saucer or well of your palette, combine the warm butter yellow and the clear bright red to make two distinctly different oranges. It can be seen that both these two colours already have an orange bias and for this reason will combine to make pure and vivid oranges. The difference between the two orange mixes is made by altering the proportion of yellow to red – *not* by using other

ingredients such as lemon yellow or wine red. Your aim is to fill the gaps with colours made from the primary immediately on either side of each gap.

If the first orange you mix turns out to be yellow-orange, paint this in the 2 o'clock position, then add more red to the mixture and paint the resulting red-orange at 3 o'clock.

Following this principle make two violets – one red-violet and the other blue-violet – and two greens – one blue-green and the other yellow-green. The object is to have a colour wheel which progresses round in a logical sequence and in even steps, and in this respect it is the greens which present the greatest difficulty. The strong, cool blue so easily swamps the delicate lemon that only a minute amount of the blue is needed, even for the blue-green.

With the wheel complete, you should know that all the colours you have painted can be tinted (made paler) with the addition of increasing amounts of water (or white pigment if you were using gouache, oils, pastels or any other opaque medium).

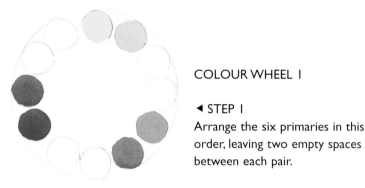

COLOUR WHEEL I

◄ STEP I

Arrange the six primaries in this order, leaving two empty spaces between each pair.

◄ STEP 2

Mix secondaries by combining only the two primaries on either side of each gap. Alter the proportion of each of these primaries to achieve a different secondary colour mix – do not use primaries from elsewhere on the colour wheel. Adding arrows like those shown here will help to remind you of the pairings.

Remember ...

The first rule of colour mixing is always to lay your palette out in the order shown here, and to remember that two neighbouring primaries will combine to produce pure secondaries.

Tip

I recommend that you continue to use a circular palette until you are entirely at home with the principles of colour wheel mixing.

Larger colour wheels

It would, of course, have been possible to make a wheel with 24 or maybe even 48 discs using only the same six colours in the same three pairings. With them we could have mixed several different oranges ranging from extremely yellow-orange through true orange (one with neither a yellow nor a red predominance) to extremely red-orange. A few different violets would have been possible, too, and many different greens. In addition we could have combined the two yellows to make a true yellow, the two reds to make a true red, and the two blues to make a true blue. This latter would have been very similar in appearance to cobalt blue, which is a true blue, namely one with neither a green nor a violet bias.

Project:

Still life using pure primaries, secondaries and their tints

This project demonstrates how you can paint a whole picture using just the primaries on the colour wheel on page 18, with their various secondaries.

Set up a still-life arrangement consisting of pure colours, similar to the one shown here. The bright colours of flowers and fruit make them especially suitable. I placed this arrangement against drapery in various shades of blue. Gift-wrap or a bright scarf could be laid on the table.

Draw the outline shapes on watercolour paper, working any size you like. Paint the arrangement in the direct method – painting one patch, object or area at a time until the work is completed. Use only the primaries from the colour wheel and their secondary mixes.

Ready-made secondaries

It has to be said that manufactured secondaries such as magentas, violets, oranges or greens are brighter and purer than the secondaries you mix for yourself. Therefore if your arrangement includes, for example, a vivid magenta cyclamen, combining crimson with warm blue will be a disappointing match, and you will have learnt the limitation of our basic six primaries. This is dealt with on page 26 under *'Palettes for Specific Subjects'*.

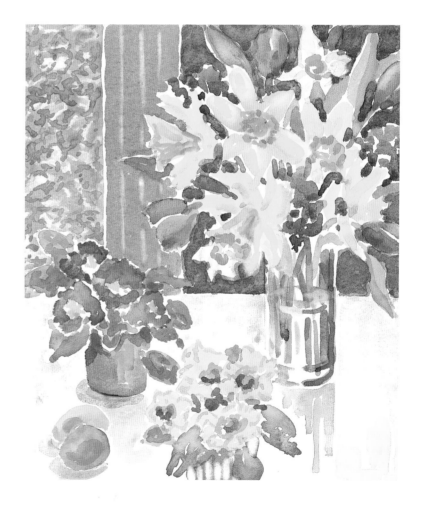

▶ STILL LIFE

All the colours used here were either primaries – yellows, reds and blues, diluted as appropriate – or secondaries – oranges, violets and greens made according to the principle described opposite, and shown in the panel above the picture.

Exercise:

Combining alternative primary pairs to produce less pure and vivid secondaries

Step 2 on page 18 shows a wheel completed with the secondaries which are the purest that our six primaries are capable of producing. However, the wheel on this page shows a different way of combining two primaries, resulting in secondaries that are much less pure and bright. For example, the lemon yellow and the wine red, both of which have a bias towards blue, have been mixed to produce oranges which are somewhat caramel or brownish in colour. It is the hint of blueness which has made the difference. Likewise the greens which result from a mix of warm butter yellow with warm ultramarine blue (both being pigments with a bias towards red) are somewhat olive and can be seen to be closer to nature's greens.

When clear bright red and cool turquoise blue are mixed the result is so impure as to be more grey or brown than violet. Again the explanation lies in the fact that the two pigments involved are both strongly biased towards a third primary, in this case yellow.

Other pairings

There are of course primary pairings which we have not yet tried. Some additional greens are possible, for example, using lemon and warm (ultramarine) blue, or warm butter yellow and cold turquoise blue. The resulting secondaries, as might be anticipated, will be only slightly less saturated than those on pages 18–19, but a little more pure and vivid than those on this page. The reason for this, of course, is that in each case only one of the constituent primaries is biased towards red.

The same principle of using two pigments at one remove from each other on the palette can be used to make violets and oranges, and again the results will not be 100 per cent pure and vivid.

Make time to try out at least some of these different pairings if you can. Practical experience is the one sure way to internalize new learning.

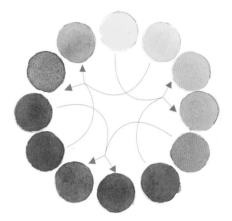

◄ COLOUR WHEEL 2
Make a wheel like the one shown here, using alternative primaries to produce less pure secondaries. Adding arrows is a useful reminder of the different pairings.

Remember ...

We can now expand our first rule of colour mixing as follows. Always lay out your palette in colour wheel sequence and remember that:

- any two primaries next to each other will yield a pure secondary;
- two primaries at one remove will produce a slightly less pure secondary;
- combining primaries at two removes from each other will produce an even less pure outcome, which may not even be recognizable as a secondary colour.

Thus this logical layout of colours avoids the need to memorize a whole raft of colour-mixing recipes.

Project:

Still life using less pure secondaries

Rather than trying to assemble objects in slightly impure secondary colours, I recommend that you draw the same or a similar image to the one you used for the project on page 19, and paint it using the primary pairings shown on the wheel opposite. These pairings of primary colours at two removes from each other on your palette will enable some pleasing natural greens for foliage. However, no bright or pure colours will be possible because, for the purpose of this exercise, no colour may be used on its own. While such a restriction is unlikely to become your normal painting practice, the exercise will undoubtedly help you to memorize this easy way of making slightly less pure secondaries.

Adhering to these pairings will be more difficult than might be imagined. Following the rule, the warm blue must be mixed with at least some warm butter yellow, however small the amount; likewise the cold blue must not be used without at least some warm (cadmium) red (and, of course, vice versa). The mix of crimson with lemon yellow does at least enable some relatively fresh yellows and oranges.

In my version here, I have allowed these warm colours to dominate in most areas, but I could just as easily have produced a work with a cool grey-blue dominance. You will find it helpful to make a colour strip like mine to demonstrate the possible permutations before you begin.

However carefully you alter the proportion of one colour to another, neutralized blues, olive greens, browns and caramel oranges will be the order of the day. Nonetheless the outcome should be pleasing, especially to those who found the results of the previous project altogether too garish for their taste.

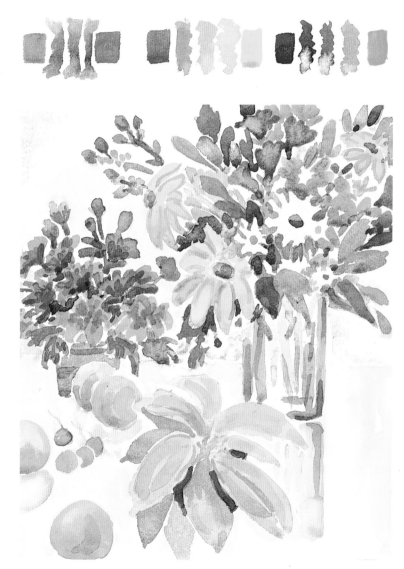

► STILL LIFE
This still life is similar to the one on page 19, but the colours have been restricted to secondary mixes made from primaries at two removes from each other on the palette.

Exercise:

Making tertiary mixes using complementary pairs

Having explored every possible pairing of our six primary colours, all that remains is to discover the potential of combining three pigments to make tertiary colours. The most systematic way to do this is to make a pure secondary by combining two primaries (see page 18) and then to introduce the third primary in various proportions, as has been done in the chart below. Thus warm yellow and red have been combined to produce a pure

secondary orange to which ultramarine blue has been added in increasing amounts. The resulting browns and greys are shown in the left-hand column at full strength. The centre column shows the same mix slightly diluted, and the right-hand one shows an even paler tint. The same process has been carried out with yellow and violet, and with red and green.

Combining one primary with one secondary in this way is also referred to as

complementary mixing; complementaries being any two colours facing each other across the colour wheel. Aesthetically pleasing together in their pure forms, when combined each pair produces an equally pleasing range of harmonious, impure colours. Comparison of the charts below with a manufacturer's colour chart will reveal that many of the mixes are closely similar to the so-called earth pigments.

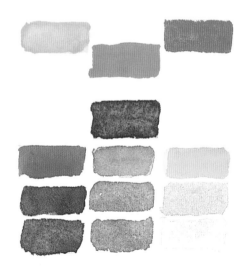

▲ ORANGE AND BLUE

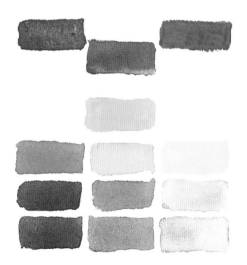

▲ VIOLET AND YELLOW

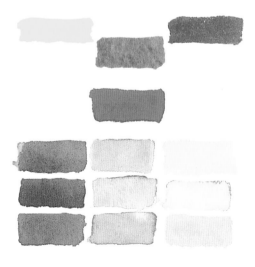

▲ GREEN AND RED

◄ A selection of tertiary or complementary pair mixes.

Project:

Still life using the blue and orange complementary pair

It comes as a surprise to many people that professional painters work to specific colour schemes rather than simply mixing to match each individual colour they see. Among such schemes complementary pairs are surely the most popular. The still life opposite shows how these complementaries can be made to work in practice – in this case, blue and orange. I have again chosen a still-life subject to allow comparison with the previous two projects.

Two approaches are possible in this project. The first is to mix up a large amount of orange using cadmium yellow and cadmium red, and to ensure that every part of the work is painted with some combination of blue and orange. The resulting impure mixes would have produced a work of great harmony but lacking any of the pure and saturated colours we associate with fruit and flowers.

The second option, used here, is to exploit the complementary pair to the full, sometimes painting with pure orange and pure blue and at other times combining the two for a subtle range of impures, as for example in the flowers, leaves and background. To increase the colour range, both warm and cold blue are used, and varying the proportion of yellow to red produces oranges ranging from extremely yellow to extremely red ones.

As with the previous project, other variants are possible, most obviously working with a yellow-violet complementary pair, or a red-green pair.

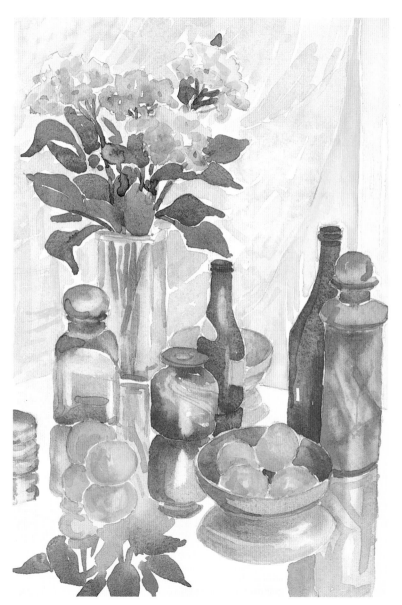

▶ STILL LIFE
Working with variants of the blue-orange complementary pair allows for a range of colours, and yet restricting the palette in this way gives a cohesive unity to the finished piece.

Exercise:

Colour recognition – can you analyse what you see?

In order to have control over your colour mixing, it is important to be able to recognize the nature of the colours around you. Here is an exercise to test your ability ... Then test yourself further: look at the colours around you and try to identify pure, slightly less pure and vivid, and neutral or almost neutral. Would you describe the colours as warm or cool, at full saturation or tinted?

▼ EXAMPLE 1

Below is a range of primary and secondary colours shown both at full saturation and tinted. Can you spot the one exception?
Answer: The caramel or slightly desaturated orange in the centre. However, although in appearance this desaturated orange is tertiary (ie mixed with a yellow, red, and a tiny touch of blue), in practice it is the product of a red with a blue bias and a yellow with a green bias (ie lemon and crimson), so only two primary pigments were used.

▼ EXAMPLE 2

While still recognizable as primaries and secondaries, the colours in this block are less pure and vivid than those in Example 1. Can you spot the one pure colour?
Answer: The butter yellow at top right.

Tip

If truly complementary colours are mixed in the correct proportions, they will produce a black or an absolutely neutral grey. It is also useful to know that the introduction of its complementary to any pure colour will darken and dull, or neutralize it.

Exercise:

Mixing to match strips from masterworks

If the 'proof of the pudding' is in the eating, the test of your understanding of colour is your ability to mix to match what you see. The colour samples on this page have been mixed to match the colours in works by three of the great masters. Test your ability to mix to match using either watercolour paint, coloured pencils, Neocolor crayons (sticks of water-soluble colour) or pastels.

The colours in Example 2 are based on a blue-orange complementary pair. Make up a similar exercise for yourself using strips of photographs cut from coloured magazines. Then use any one of the colour schemes shown here to create a painting based on one of your own drawings, or on a black-and-white photograph.

▼ **EXAMPLE 1**
These colours were taken from a Monet landscape.

▼ **EXAMPLE 2**
These colours come from a still life painted by Cézanne.

▼ **EXAMPLE 3**
These colours come from an interior painted by Matisse.

Laying out palettes for specific subjects

Although there is no better way to gain control of colour mixing than by limiting yourself to two of each primary colour and making a colour wheel with them, the time soon comes when you will need to make additions or – in the case of landscapists – substitutions.

Flower painter's palette

When it comes to painting flowers the rule is, the more pure colours you have the better. Although everyone has their favourites, and although the colours listed at right do not purport to be comprehensive, the ones shown here are the most important additions, for the flower painter, to our original six primaries.

Most of the additional pigments are primaries. The two secondaries, an orange and a violet, can be mixed as we have seen but the ready-made versions have greater purity and saturation, which is important for the flower painter. They also dispense with the need for laborious mixing.

The optional colours – the greens – are a special case, however. Having seen the myriad possibilities of combining various blues and yellows, we must acknowledge that ready-made greens are definitely 'optional extras'. The pure greens

Flower painter's palette

LEMON YELLOW
Cool with green bias. One of our six basic pigments (see page 8).

WINSOR YELLOW OR AUREOLIN
Both true yellows, neither warm nor cool, and very transparent.

CADMIUM YELLOW
Warm with an orange bias. One of our six basic pigments (see page 8).

CADMIUM ORANGE
Although opaque like all cadmiums, a useful ready-made orange.

CADMIUM RED
Warm with an orange bias. One of our six basic pigments (see page 8).

PERMANENT ROSE
An inimitable red, lying somewhere between clear bright red and wine or crimson.

ALIZARIN CRIMSON
Cool with a violet bias. One of our six basic pigments (see page 8).

MAGENTA
Another indispensable addition – no permutation of blue and red can produce anything even close to it in colour brilliance and saturation.

WINSOR VIOLET OR MAUVE
More brilliant and saturated than home-made varieties.

FRENCH ULTRAMARINE
Warm with a violet bias. One of our six basic pigments (see page 8).

COBALT BLUE
A true blue. Mix something similar by combining warm and cold blues.

WINSOR BLUE GREEN SHADE
Cool with a green bias. One of our six basic pigments (see page 8).

OPTIONAL EXTRAS

SAP GREEN OR PERMANENT SAP GREEN
An intense yellow-green which can be rendered more natural by the addition of either raw or burnt sienna.

VIRIDIAN
A blue-green, which again is rendered more natural by the addition of either siennas or small touches of red. Mixed with alizarin crimson, it provides a shortcut to black and neutral greys.

suggested all afford shortcuts to mixing, but since there are few pure greens in nature, these colours can all too readily become obtrusive. They should therefore be used judiciously, and preferably used in combination with other moderating colours.

Landscape painter's palette

While flower painters would *add* to the basic six pigments for the sake of both colour saturation and as a shortcut to mixing, on the whole landscapists tend to aspire to a relatively limited palette for the sake of colour harmony. Working outdoors, often 'against the clock', they have perhaps an even greater need for mixing shortcuts, while at the same time aiming for the most part to eliminate opaque pigments. For this reason I have chosen to omit the cadmiums from my landscape painter's palette. While their opacity is imperceptible when used on their own – as, for example, in poppies or daffodils – it is more noticeable in strong mixes of greens and browns.

Regarding the greens, I must add the same caution here as for the flower painter's palette opposite. Alternatively, try Hooker's green for your landscape palette.

Students often tell me that they read what appears to be conflicting advice in books about landscape pigments, and in a comparative study this appears to be true. On closer inspection, however, I find that the majority choose one pure and one impure yellow, one pure and one impure red, two blues and perhaps one or two ready-made greens. Some would add black, or a grey such as Payne's grey. Since there is quite a list to choose from, the marketing names may vary – but nonetheless, the landscape palette given here is a fairly standard one.

Landscape painter's palette		
WINSOR YELLOW OR AUREOLIN Pure, true yellows.	FRENCH ULTRAMARINE Warm blue.	
RAW SIENNA Impure yellow.	WINSOR BLUE Cold blue.	
PERMANENT ALIZARIN CRIMSON OR PERMANENT ROSE Pure reds.	OPTIONAL EXTRAS	
BURNT SIENNA Impure red – a 'foxy' brown.	PERMANENT SAP Yellow-green.	
LIGHT RED Impure red – 'brick' or 'rust'. Somewhat opaque, opacity insignificant in dilute washes.	VIRIDIAN Blue-green.	

Tip

When adding pure colours to your basic palette for flower painting, place them in the correct colour wheel sequence. The additional *impure* pigments suggested opposite for landscapists, I prefer to lay out at the end of the palette, *after* the pure pigments.

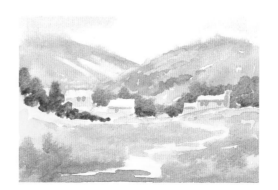

◀ LANDSCAPE WITH BUILDINGS Replace opaque, pure colours with transparent, impure ones to maximize transparency and shortcut mixing nature's greens and browns.

Learning to draw

'Anyone can learn to draw.' What expressions of incredulity I see whenever I make this assertion! I have of course to add: ' ... if they are really motivated.' That has to be said because the ability to draw consists of five distinctively different skills, which have to be learnt separately and then put together, and of course this takes time.

The five skills are:
- Observation of shapes.
- Ability to measure and compare proportions.
- Knowing how to assess degrees of angles.
- Discovering the relative position of one object to another.
- Observation of 'negative' shapes – the spaces between objects.

When you watch an artist at work on a drawing, it can seem as if the drawing is growing by magic, but if you could tune in to the thought processes involved you would appreciate that the artist is using first one way of observing and then another. Because learning five new skills at once is difficult, we shall learn them one by one, eventually putting them all together.

Learning to draw can be compared to learning to drive. If you can already drive a car, you will know what it is like to have to use several different skills at once – steering, gear changing, and speed control with accelerator and brake, and responding to the actions of others on the road. Like learning to drive, learning to draw takes time but your effort will be well rewarded.

Consider the importance of drawing to artists. It can be an art form in its own right, a means of recording people, places and events, and for watercolourists, of course, it is a way to establish the main shapes before starting to paint.

The first four drawing skills are covered in this lesson, while the fifth is so important that it merits a whole lesson on its own.

Aims

- To instil slow, careful and specific observation
- To enable accurate representation by means of taking and comparing measurements; assessing angles; and discovering the relative positions of objects
- To encourage regular practice of observational drawing

Remember

These are some things that can inhibit your drawing progress. Make a mental note of them before you put pencil to paper.

Speed Artists can often be seen drawing rapidly, but let me assure you, they did not always do so. At first the process is slow and laborious because all the skills demand careful looking, and that cannot be hurried.

Drawing what you see, not what you imagine or remember Ask anyone to draw a tree without looking at one, and they will always be able to produce something, however crude and unsophisticated. We all have stored images in our heads and it is easier to use these than to do some really careful looking. You are more likely to fall into this trap when working quickly, so again slow down!

Drawing what you see, not what you know It is difficult to draw some things correctly because of what you know about them. Take this box as an example. In the position shown, it is correct to use one straight line (here marked in red) to portray the left-hand edge of both the front and the top. In fact you know the front surface and the top surface of a box to be at right-angles to one another, but this is not always what you *see* and therefore *not* what you must draw.

With these warnings in mind we can make a start.

Project:

Drawing a still life on mirror tiles

Most beginner students would find this an intimidatingly difficult drawing task, partly because of the confusion of objects and their reflections, and partly because man-made objects are more daunting than such natural forms as flowers or trees. There is a need for accuracy if the objects are not to appear as a collection of mis-shapes. The following pages offer exercises to help you understand and practise the drawing skills necessary to tackle this and other quite complex subjects. If drawing such an arrangement presents you with little difficulty your drawing skills are probably perfectly adequate, and you should therefore set up, draw and paint a similar arrangement, and then move on to the next lesson. Others would perhaps like to complete Lessons Two and Three before attempting this project – it will certainly test the efficacy of the drawing lessons.

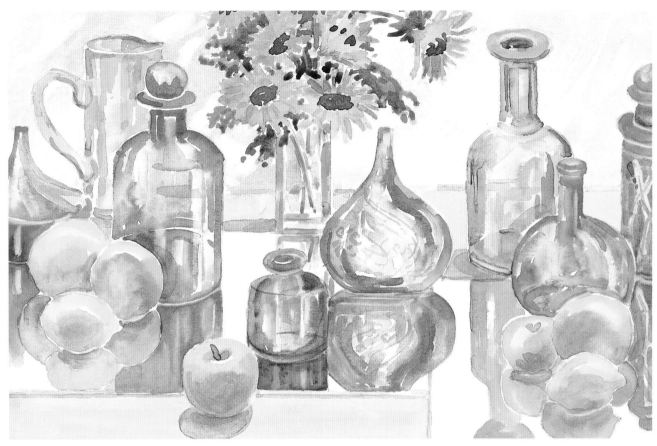

▲ STILL LIFE ON MIRROR TILES

Exercise:

Drawing a silhouette

This page shows a silhouette drawing I made of part of the still life on page 29. Starting at one end, my eye travelled slowly around each object or the back edge of the table until it arrived at the opposite end. As my eye travelled, so my hand, holding the pencil, moved slowly across the paper, recording the eye's journey.

Since this is quite a complicated subject I suggest that you first try something more simple. Throw a dark coat or blanket on to a table against a pale wall. Fasten a piece of A3 cartridge paper to your board,

▲ DRAWING A SILHOUETTE
The outline of part of the still life on page 29 looked like this. I filled in the outline with a grey wash to emphasize the shapes.

and sit facing the wall with the board resting on the edge of the table and on your lap. You may draw large or small as you please, but before you begin, take time to look carefully at the outline of the coat. You are not concerned with the creases or any other details of the coat, only with its silhouette. Note which is the highest point on the 'horizon', and which is the lowest. Is the edge gently curving or perhaps a series of angular lines?

Begin when you feel ready. It does not matter whether you find it easier to work from right to left or left to right. For many people there will be a temptation to draw in a series of tentative 'feeling' lines, but your pencil must travel simultaneously with your eye, making one positive and continuous line recording the eye's slow journey. You will need to give occasional glances at the drawing to see how it is going, but most of your attention should be focused on the edge of the coat.

If you have not done much drawing it will be difficult to keep things in proper proportion, but that skill comes later, so for now just do the best you can. There is no need to use a rubber since the point of the exercise is to experience simultaneous slow looking and recording,

▲ ABSTRACT SILHOUETTE
The outline drawing of a coat against a light wall might look like this. Again the outline has been filled in to define the shape.

and to appreciate the vital link between the seeing eye and the recording hand.

Next, try drawing a real horizon in the landscape, or the silhouette of a still-life arrangement like the one shown here. These subjects will seem more difficult because of the anxiety to make these specific subjects look realistic. Don't worry – just look carefully and work slowly and all will be well. Adding a wash of colour to your efforts will add emphasis to this way of thinking. Do not be tempted to add any other details or any light and shade.

▼ ADDING DETAIL
Including detail within a silhouette comes after you have mastered the technique of hand–eye coordination involved in drawing a basic outline.

Project:

Painting the silhouette of buildings

Towns and cities offer the opportunity to draw skylines and sometimes a whole series of overlapping silhouettes consisting of angled lines. A group of farm buildings will provide a similar exercise. In my example here, I first drew the outlines of hill and castle with an HB pencil, then laid a pale, warm wash over the whole paper, lifting out a few small areas on the buildings with a piece of blotting paper while the paint was still wet. When the wash was dry, I superimposed a second wash for the hill, bringing it down to outline the castle. After some pencil drawing of the inner shapes of the castle, I added a few areas of shadow and some brushmarks for the windows. The dark tree shapes were superimposed behind the castle, and then some foreground brushmarks were added when the previous washes were completely dry. *(Note: there is a step-by-step sequence on pages 44–5 which demonstrates painting a similar landscape subject by this layer-on-layer method.)*

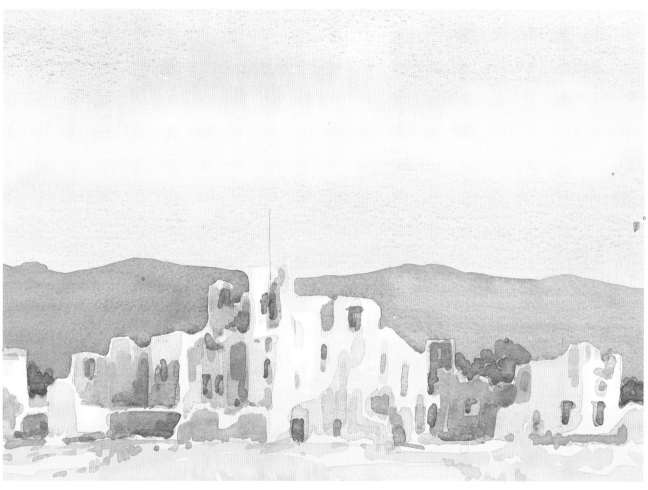

▲ MIDDLEHAM CASTLE
The long outline of the castle buildings and the hills behind provided an ideal opportunity to practise the technique of silhouette drawing.

Exercise:

Measuring with pencil and thumb

For most people the problems of the silhouette exercises on the previous pages centre around proportions, ie the difficulties of making each separate part of the drawing in correct proportion to all the other parts. In time you may feel able to assess the relative size of most objects without needing to take and compare measurements. Nonetheless I for one continue to take measurements quite frequently to verify my observations.

Measurements are taken with a pencil held at arm's length. To ensure that pencil and eye are always the same distance apart, 'lock' your elbow joint so that your arm is stiff and fully stretched. So with elbow 'locked' and one eye closed for monocular vision you are ready to begin.

Tip

People often think that the measurements taken will affect the size of the drawing – this is not the case. Measurements are taken to discover the comparative size of things. The drawing itself can be large or small, as long as the objects are drawn in correct proportion to each other.

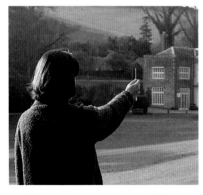

▲ Measuring with the arm fully extended.

◄ VERTICAL MEASURING
In my example, by aligning the end of the pencil with the ridge tiles and sliding my thumb down the pencil until it is in line with the guttering, I have a measurement which can be compared with some other part of the building. To compare this measurement with the height of the wall beneath, I next move the whole pencil down, still keeping my thumb in place, until the tip is in line with the guttering. This shows me that roof and window are similar in size. Moving the pencil down once more reveals that the whole height of the wall is twice that of the roof.

COMPARING WIDTH WITH HEIGHT

To discover whether the building is higher than it is wide, I now line up the tip of the pencil with the ridge tiles and slide my thumb down until it is in line with the base of the building. I now have to rotate my hand through 90 degrees in order to compare this measurement of height with one of width.

▲ BOXING UP
When trying to draw a single object in correct height-to-width proportion, some people find it helpful to create a rectangle first. The object may be an irregular shape but if, as in this example of a tree, the height is found to be one and a half widths high, then a rectangle of that proportion can be drawn and the tree fitted into it. The method is called 'boxing up'.

Exercise:

Drawing a bottle using the boxing-up method

Step 1

Put the bottle on the table in front of you about 30cm (12in) beyond your reach. Sit with your drawing board angled between your lap and the edge of the table. Measure across the bottle at its widest point. Then, rotating your hand through 90 degrees, determine how many times this measurement will fit into the height of the bottle. In my example the answer was almost three times.

Make your drawing any size you wish by first drawing two lines at right angles and then marking the proportions with a series of dots or short dashes.

Step 2

Now add two more lines to complete a rectangle. Think of this as a box within which the bottle would fit snugly. Next, take and compare two vertical measurements to determine the points at which the straight sides of the bottle begin to curve inwards to form the shoulders. In my example this point was found to be one third of the total height, and I have marked this with two longer dashes.

Step 3

Next draw a central, vertical, dotted line and establish the width of the bottle neck with two more dashes. It will be too narrow for an accurate measurement so make your best guess and place the two dashes equally spaced on either side of the dotted line. Before connecting the dashes to draw the shoulder shape, try closing one eye and tracing this curve in the air with your finger.

Step 4

Try turning the paper upside down to draw the second shoulder as a mirror image of the first. Now compare your drawing with the bottle. If it looks a little squat, draw the base ellipse on the outside of the rectangle; if too tall, draw the ellipse on the inside. The extent of the base ellipse will be more obvious if you place a ruler or piece of paper on the table just touching the bottle (shown here as a green line). We often make such ellipses too shallow so look carefully at how the line curves upwards from the point at which ruler and bottle touch.

Tip

Some students find it very tedious to take and compare measurements, preferring to make the drawing to the best of their ability and then compare the result with the subject. The drawing is then corrected as they feel necessary. My own view is that whatever works for you is right for you.

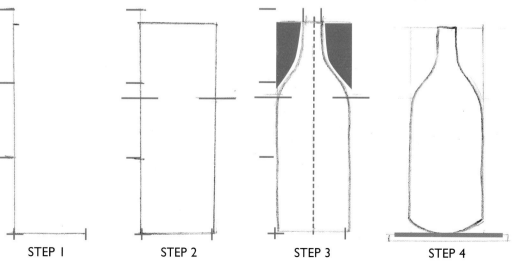

STEP 1 STEP 2 STEP 3 STEP 4

Exercise:

Assessing angles

The ability to observe silhouette shapes, take comparative measurements and assess degrees of angle are three drawing skills which you must practise concurrently, moving from observing outlines to proportions and then angles and back again as need dictates. Before you go on to develop any more observational skills, try the exercises on these two pages, and on page 38 look at the devices used by artists to help them see angles accurately.

Step 1

Since I was bad at geometry, I have had to find another way to assess degrees of angle in drawing. I appreciate that for many it is enough to observe that a line is at, say, 45 degrees to the horizontal (or perpendicular), but for others like me I suggest thinking in terms of the hands of a clock.

Step 2

Holding my pencil out horizontally – that is, parallel with my eyes – against the ridge tiles of a roof I can see not only that the roof slopes down to the right but also the degree of that slope. With my red pencil now at the same angle as the hour hand at 3 o'clock, I judge the ridge tiles to be like the minute hand at 17 minutes past the hour.

Step 3

Of course if I am trying to assess a line closer to the vertical than the horizontal, I must hold my pencil up vertically next to the line. Now my red pencil is akin to the hour hand pointing to 12 o'clock, and the angle of the gable I judge to be at the same angle as the minute hand pointing to 6 minutes past the hour.

Exercise:

Working with silhouettes, proportions and angles together

The aim of this exercise is to try out the three drawing skills that you have learnt so far. The outcome is unlikely to be wholly satisfactory because there are still two more observational skills to be learnt, but the results will be better than if you had never given any thought to silhouettes, proportions and angles.

Sit facing the corner of the room, and start by drawing a vertical line for the point at which the two walls meet (a red

line in my drawing below). Hold out your pencil above eye level but parallel with the floor and line it up with the point where the walls meet the ceiling. See these two ceiling lines as the hands of a clock – in the diagram here, the 'minute hand' reads roughly 10 minutes before the hour, and the 'hour hand' reads at 2 o'clock (green lines).

When you have drawn these two lines, turn your attention to the outline shapes of whatever objects stand on the work surface or desk. As you start to draw their silhouettes you will need to break off to check the proportions of each object, comparing its height to its width. Having drawn one object, compare its size with the one next to it. If there are angles involved, perhaps you should assess them, too, with your pencil held out horizontally or vertically as appropriate, before returning to more outline-shape drawing. This is how a drawing progresses, with the artist using first one way of observing and then another. Imagine how much easier it will be when you have all five drawing skills at your disposal!

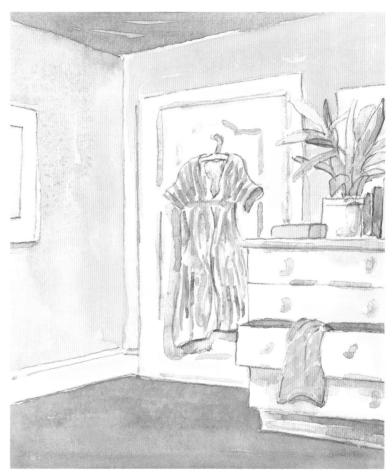

◀ ▲ **THE STRIPED DRESSING GOWN**

Seeking relationship

This fourth observational skill is easy to understand, easy to apply and really useful. It is a means by which to ascertain the relative position of one object or part of an object to another, and it can be applied to absolutely any subject.

▼ PLUMBLINES

Hold up your pencil vertically in front of the object you are drawing, with your arm outstretched. By moving the pencil up and down vertically, you can discover what is immediately above or immediately below the object you are drawing. In my example, I discovered that the left ear was directly above the left knee. I drew a dotted line to represent where I had held out my pencil and was able to place the knee and the chair leg directly below the ear, ie on the dotted line.

▼ SPIRIT-LEVEL LINES

In the same way holding out your pencil horizontally enables you to discover what is to the right or to the left of what you are drawing. Again, I have used a dotted line to record these horizontal alignments.

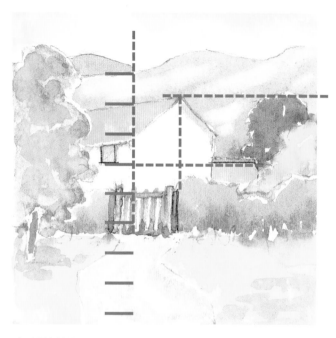

▲ MEASURING MARKS AND PLOTTING LINES

These dotted lines denoting 'plumbline' or 'spirit-level' connections are called 'plotting lines', while the dots and dashes we used earlier to record our findings about the proportion of objects are known as 'measuring marks'. Together they show how this drawing was created. While you are learning to draw, I recommend that you leave these marks and lines visible in your drawings. In time the observation of these relationships will become second nature, something you do visually and automatically, without necessarily recording them on paper.

Project:

Painting a still life

I suggest that you practise your skills using a still life subject because it is convenient, but you might prefer landscape for a change. Skills of observation apply equally to every subject.

Drawing the composition

Use all the techniques described so far to measure and compare proportions and to discover the relative position of objects. Work on cartridge paper using an HB pencil, and leave your measuring marks and plotting lines visible in the finished drawing. Take care not to draw too small, which can make the job more difficult.

Painting the composition

Now repeat the exercise on watercolour paper using the same techniques but without actually putting in the measuring marks and plotting lines. You should be able to do this second drawing a little faster because of what you learnt in the first drawing, after which you can apply watercolour paint using the direct method – that is, painting one patch at a time. If any area needs strengthening, you can safely superimpose a second layer of paint provided the first layer is absolutely dry.

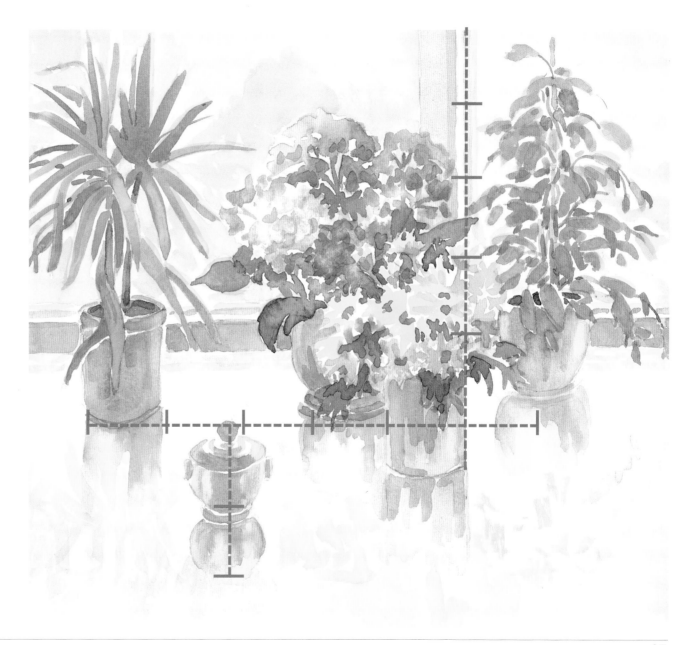

Gadgets and 'gismos'

I am often asked if I approve of this or that aid to drawing, most commonly erasers and rulers. My answer is that I approve of anything that makes observation more accurate and drawing easier. Erasers can, however, damage the surface of watercolour paper and should be used sparingly. As for lines drawn with a ruler, they can look too formal for a painting, and drawing them freehand does get easier with practice.

▼ GRIDS BEHIND OBJECTS

A curved shape like this teapot can be easier to draw with a grid of squares behind it. Place the object as close to the grid as possible, and rule a corresponding grid on your paper – use large squares for a large drawing, small ones for a small drawing. Start the drawing by placing a series of dots denoting the points at which the curves are seen to cross the grid behind the teapot.

▼ GRIDS IN FRONT OF OBJECTS

It is possible to rig up a transparent grid in front of objects, but more useful to have a viewfinder with a window grid like the one here to hold in your hand and use indoors or out. Holding the grid up in front of your chosen subject will help you to assess the position and proportions of the different objects you are seeing.

▼ MAKING A VIEWFINDER WITH A WINDOW GRID

For any viewfinder to be effective, the viewfinder and the paper on which you intend to work must be of the same proportions. One way to do this is to place a postcard in the corner of your drawing pad or paper, and rule a line from that corner to the one diagonally opposite on the pad or paper. Now trim the postcard, indicated here as a red dotted line, so that the diagonal now dissects two corners of the card. A window of any size cut in the card will be of the correct proportions to the paper, *provided that the diagonal line runs through the opposite corners of that window.*

Use a stout piece of transparent plastic packaging to 'glaze' the window and add a cross with a marker pen as illustrated. This will help you to locate objects in the correct quarter of the drawing.

▼ ANGLE MEASURER

Two small pieces of wood, screwed together in the centre just tightly enough to allow you to alter their angles to one another, is another handy home-made 'gismo'. Hold it out and line it up with the angles you are studying, then bring the gadget down onto your paper to check the angles against your drawing.

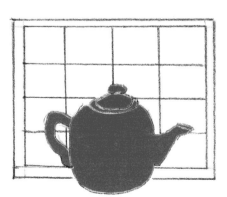

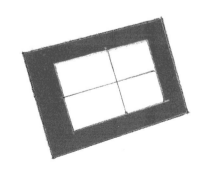

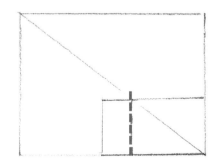

Exercise:

Drawing on clingfilm

This exercise is to help you test the accuracy of your observation. Sit or stand within touching distance of any window through which you have a view of buildings – ideally a view which you would consider challenging from a perspective point of view.

Draw the buildings on cartridge paper, using the usual techniques for measuring proportions and assessing angles. Next smooth clingfilm over the glass and, sitting or standing as close as possible to your original position, trace the view onto the clingfilm using a marker pen. You will need to keep very still in order to maintain a single viewpoint, and will probably find it easier to close one eye.

Remove the clingfilm carefully and lay it down on a white surface or drawing paper, gently easing out any creases or wrinkles. You will now be able to compare your drawing with this tracing. There may be some surprises!

▶ Tracing a view of buildings on to clingfilm pressed against a window pane.

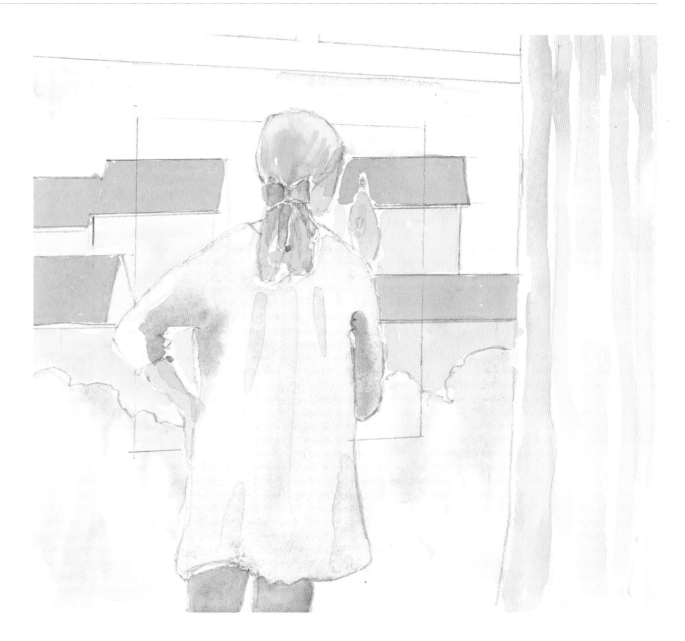

Negative shapes

In drawing and painting, the shapes of objects and the shapes of the spaces between the objects have an equal importance. This is difficult to grasp because throughout our lives we learn to recognize and give names to objects, but we rarely recognize the spaces between those objects. In art, these 'in-between' spaces are referred to as 'negative shapes'.

The ability to see negative shapes is our fifth and final drawing skill. The exercises on this page aim to help you tune in to this new way of seeing the world. After an exercise using negative shapes in drawing, further exercises show the significance of negative shape in composition and in watercolour method and process.

Aims

- To further enhance drawing skills through observation of the shapes of spaces
- To learn the equal importance of positive and negative in drawing and composition
- To learn the significant role of negative shape in the watercolour process
- To become accustomed to observing and thinking in negative as well as in positive terms

Exercise:
Stack of chairs

In this drawing of a stack of school chairs, only the spaces have been drawn. Indeed the chairs were so jumbled up that it was difficult to see which leg was attached to which seat. For a simple first exercise, try drawing the spaces between the legs of a tea trolley or a chair with a slatted backrest. Close one eye and try to see these gaps as precise shapes.

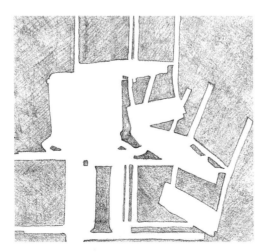

Exercise:
Pot plant

The gaps between the branches of winter trees or the negative shapes in a large-leafed pot plant offer a similar drawing exercise. It will be difficult at first to resist the temptation to draw the branches, or leaves, rather than the gaps between them, but do your best. Here the window frame helps to 'trap' the shapes. I used water-soluble graphite pencil for emphasis.

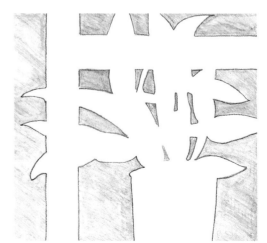

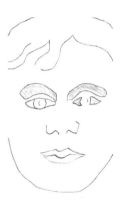

Exercise:
Face in mirror

Look at your face in the mirror and instead of drawing nose, eyes or mouth, draw the shape of the space between features, such as that between brow and upper lid, or draw the white of the eye rather than the iris.

Project:

Drawing the still life

Arrange some objects from your kitchen cupboards and drawers on a table, placing some near the front and others further away. Allow some objects to overlap others, but do not allow the negative shapes to be much larger than the shapes of the objects. Coasters, table mats, or squares of coloured paper can all be used to break up the large spaces into smaller ones.

Start somewhere in the middle by drawing one of the shapes between the objects, as marked red in the example here. Every time you complete a negative shape outline, scribble in the area within the outline with a soft graphite or coloured pencil to emphasize it.

Continue the drawing, working outwards from your first shape and alternating between working negatively and positively. When you reach the outer edges of the arrangement, use a viewfinder with the same proportions as your paper to complete the drawing, working both negatively and positively until you have finished.

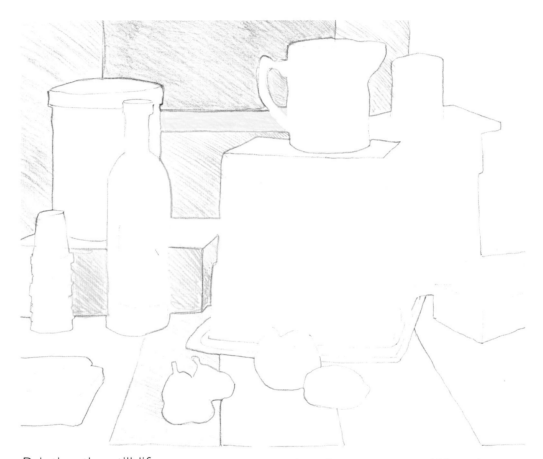

◄ KITCHEN
STILL LIFE

Tip

This would be a good time to return to any of the earlier drawing projects and try them again, using all five of the observational skills. Use any drawing medium you choose, or watercolour paint. The more you practise, the sooner you will be able to draw without giving conscious thought to any individual drawing skill.

Painting the still life

Repeat the drawing, this time on watercolour paper and using a water-soluble pen. This will force you to make a bold drawing without correcting any lines along the way. Again, scribble in the negative spaces and then turn the scribble into wash with a damp brush. Alternatively draw with a non-soluble pen and then paint the spaces with a bright colour.

Exercise:

Checking your composition

All the shapes in a painting are seen in relation to the format or frame within which they are placed. For me, a few small objects, or a face or a figure floating in a sea of space lacks excitement. I prefer the shapes of objects to touch or even perhaps disappear off the edge of the rectangle. I have some L-shaped pieces of white card (see illustration top right) which I use to check my composition. When a work is complete I put it on the floor, lay the L-shapes around the edges, and slowly move them towards each other to see if that improves the composition. The shapes of the objects remain the same, but shapes of the spaces become smaller and more interesting.

You can make your own L-shapes by cutting an old or damaged mount into two pieces, or you can simply use four long strips of white card (white seems to set off most watercolour paintings to best advantage). Try them around any previously painted work and experiment to see if some judicious cropping will improve the composition.

Similarly I dislike objects to be crammed too closely together with few or no space shapes between. In the two still-life illustrations on this page the positive shapes (the objects) are much the same, only the negative shapes (the spaces) are different. Which do you prefer?

On the opposite page is a project which I hope will help you to plan the shape and size of the negative spaces before you start to paint. The objective is to enable you to see that positive shapes and negative shapes are but two sides of a coin, and of equal importance in any picture.

▲ L-SHAPED PIECES OF CARD

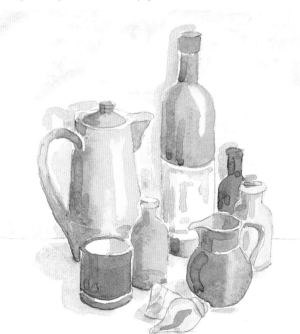

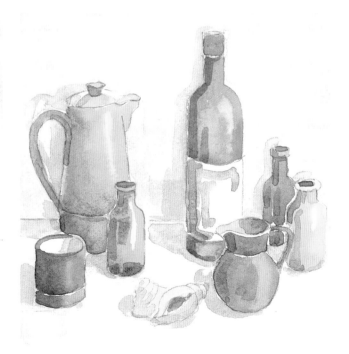

Exercise:

Drawing and painting the negative and positive shapes of leaves

First arrange a number of large and shapely leaves, or flat, disc-like flowers such as pansies, on a piece of paper. They should overlap one another and some should extend over the edges of the paper. Then frame the arrangement with L-shapes or four strips of white card.

Drawing the negative shapes

Use the leaves as templates, drawing around their edges so that you outline the shapes of the bare paper visible between them. Use your thickest, ready-loaded pen or a soft pencil. Where a negative shape touches the edge, continue the pen line around the paper's edge so that every white shape you draw is totally enclosed by the line of ink.

Repeat the exercise, this time drawing the negative shapes from observation using an HB pencil on watercolour paper. This will be easier if the leaves are arranged on a piece of paper the same size as that on which you are drawing, and the arrangement set on a chair or low table so that you can look down on it.

Such an exercise is an excellent opportunity to paint the background using wet-in-wet techniques. Simply wet one area at a time and touch in strong colour, leaving it to run and bleed as it will. Complete the work with a minimum of pale colour on the leaves.

▶ NEGATIVE LEAF SHAPES IN WATERCOLOUR
▼ NEGATIVE LEAF SHAPES IN HB PENCIL

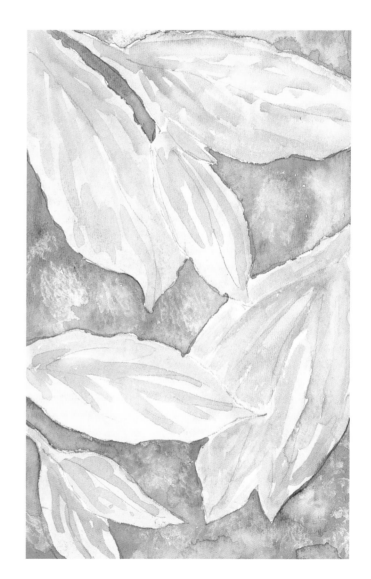

Project:

Painting a landscape using the layer-on-layer method

The ability to see and think in terms of negative as well as positive shape is essential to watercolour painters. Lacking any white pigment, white flowers are created by bringing colour up to and around unpainted paper. The same principle is used for white sails and cascading waterfalls and really anything which is perceived as an absolutely white shape. However, these are relatively simple examples and only part of the story.

Watercolour students must learn to think in terms of wash areas and this is especially important when working in the layer method. The painting on page 31, for example, shows a hill; the top edge of which is a positive shape – the crest of the hill itself – while the bottom edge is a negative shape, the outline or silhouette of the castle.

Layer painting produces works of great harmony because the superimposed layers of colour are all influenced by those that lie beneath them. When trying this layer-painting project, remember to allow each layer of paint to dry completely before superimposing the next one.

STEP 1

Choose any simple landscape image where it is possible to think of the space in terms of a series of planes receding into the distance – in this case, a foreground field with tree and path, then buildings and a bank of dark trees in the middle ground, and behind that lies a distant hill.

After outlining the main shapes with an HB pencil, lay a pale base wash of warm yellow to cover the whole of the paper. I have used dilute raw sienna here. Allow this wash to dry completely before Step 2.

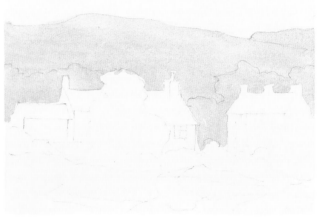

STEP 2

Superimpose a wash of pale blue-green on the distant hill, painting negatively around the house and the foreground tree. Note that even if this wash were to be pale blue it would still take on a greenish tinge because of the underlying yellowish colour. Again, allow the wash to dry completely.

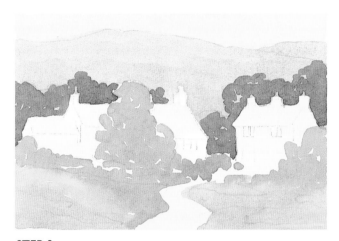

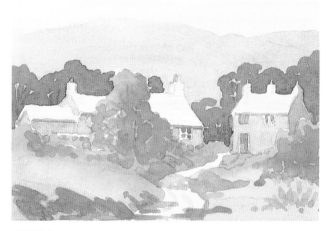

STEP 3

Now superimpose the dark band of trees using a strongish mix of cool blue such as Winsor blue with burnt sienna. This dark green colour must be applied in the shape of the trees along the top edge, but along the bottom edge it must be painted negatively around the house and foreground tree.

When dry, prepare three separate mixes of slightly stronger raw sienna, a yellow-green, and a warm brown such as burnt sienna. Apply these randomly to the foreground and the foreground bushes and tree, allowing them to run together wet-into-wet.

STEP 4

The picture can be completed with a light wash of colour to the front of the building, some shadow on the foreground bushes and tree, and perhaps some cast shadows in the immediate foreground to increase the illusion of recession. A second wash will give shadow to the gable end of the building.

Note that the original warm yellowish wash remains virtually untouched on the roofs and sky and the foreground path – i.e. all the lightest areas – while it has a unifying and harmonizing effect on all the colours which were later superimposed.

Three-dimensional form – the art of illusion

The top priority for most beginner painters is to achieve a convincing representation of reality. Competence in colour mixing and the ability to draw objects accurately and in correct proportion are not enough. The missing element is the illusion that the objects have solid form and are set in real, three-dimensional space.

The flat surface

While Renaissance painters celebrated their ability to create this illusion of solidity so convincingly, in more modern times many artists have chosen to acknowledge that paper and canvas are flat, and to make it clear that whatever marks they put onto that flat surface are always, first and foremost, paint. Some, like Matisse (see right), used recognizable images, but rendered them as decorative arrangements of lines, shapes and colours. Some of Turner's works (see opposite) are so diffused with light that the features of the landscape seem to melt away, and might be considered 'semi-abstract' rather than representational. Others have abandoned representational images altogether, and although all such works may be thought of as abstract, it is as well to remember that

their creators were pursuing many different interests and priorities.

Mastering the basics

Learner painters usually feel quite strongly that before entering into experimental art they must master representational images, and that has been my own experience, too. Plenty of opportunities for experimentation are offered later, but for the time being let us accept that representational art is about creating an illusion, and try to discover how that illusion can be achieved. The two main elements – form and space – can be considered separately; this lesson is devoted to the different ways of creating an illusion of form.

Aims

- To emphasize the element of illusion in painting
- To produce a convincing illusion of form by means of tone, colour and brushmark

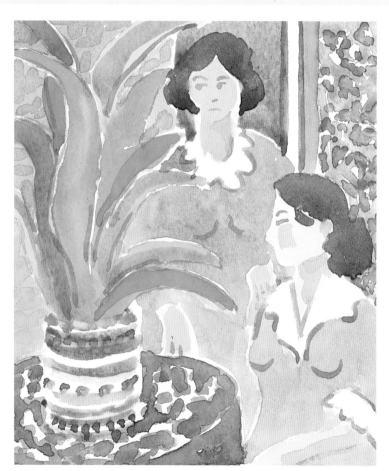

▲ HOMAGE TO MATISSE

In this painting in the style of Matisse, I show how the main forms can be 'flattened out' as blocks of colours, emphasized in places by outlining. The effect is decorative rather than realistically representational.

▼ HOMAGE TO TURNER

The two aspects of three-dimensional illusion are space and form. Here, in my painting in the style of Turner's *Norham Castle*, the hills are so diffused with light that their form – the undulations, rock formations and woodland areas – is scarcely visible. However, the image has an illusion of spatial depth, which has been achieved by use of greater tonal contrast in the foreground than in the background. View this page upside down to see this contrast more clearly.

Basic three-dimensional forms

'Everything in nature is modelled on the sphere, the cone and the cylinder. One must learn to paint from these simple forms; it will then be possible to do whatever one wishes.' This is one of the most frequently quoted sayings of Cézanne; in order to include man-made objects, I would also add 'the cube' to his statement. Here is another – and perhaps even more significant – quotation of Cézanne's: 'Contrasts and relations of tone – there lies the whole secret of drawing and relief.'

Taking these two quotations together, I understand that to draw accurately we should give attention to basic shapes and to the distribution of light and shade if we are to achieve the illusion of the form of objects.

I believe it is important to study forms in tone without colour, before moving on to polychromatic (many-coloured) painting, because colour has uses and problems of its own when one is trying to create the illusion of form.

Exercise:
Drawing the basic forms

The drawing on this page shows Cézanne's basic forms, with the addition of my cube. I suggest you draw them before attempting the painting project opposite. Try to find a white box and a white ball, and construct a matching cylinder and cone by rolling some stiff cartridge paper into shape. If you can't find white objects, plain cream ones would make the best alternative. Place them on a white surface, well below eye level and in some strong side-lighting from either a window or lamp. This will throw them into relief, making it easier to see the shadowed areas.

First draw the outline shapes with an HB pencil, remembering to include the shadows below them. Then take a softer grade, 4B or 6B and, using hatching or scribble, record the shadows. It can be easiest to do this in three stages:

Step 1
Identify the lightest areas and scribble lightly on all the rest.

Step 2
Identify the darkest areas and superimpose a second layer of hatching or scribble, applying more pressure with the pencil.

Step 3
Do a little 'fine tuning' for any intermediate tones.

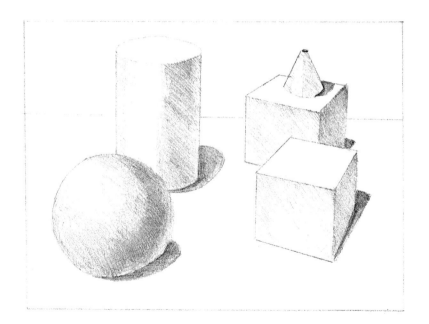

Project:

Painting a white still life in monochrome washes

Find a group of white objects, preferably all with the same degree of whiteness. Arrange them as for the drawing project, in good directional lighting.

Draw the outline shapes on a piece of watercolour paper and prepare a light wash of neutral colour. You might remember the grey we produced by combining a cold blue with a warm red such as cadmium, or you could mix a warm blue (ultramarine) with burnt sienna. Either of these should produce a more or less neutral grey.

Follow the same step sequence as for the drawing project opposite:

1. Identify the lightest area and apply a wash of pale grey to everything else. For a soft edge to this wash, run a damp brush along the edge nearest to the light while the paint is still wet. Allow to dry completely.

2. Using a stronger mix of the same two colours, apply a second layer to those areas you see as darkest, again softening the edge where necessary. The soft-edge technique used here will probably make it unnecessary to do any fine tuning.

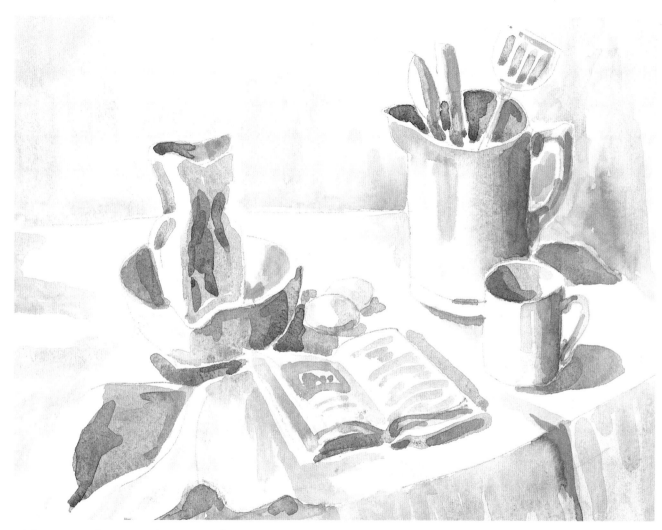

There are, of course, other ways of applying the paint than in the layering method, and you should try whatever method you prefer.

▲ PANCAKE DAY
It isn't easy to find objects that are all equally white, but do your best – I found most of these white objects in my kitchen cupboards and used them to set up this still life.

Using the tonality of colours to create three-dimensional form

I said earlier that colour has both uses and problems when it comes to creating the illusion of form. When working with different-coloured items, the problems stem from the fact that colours themselves have different tones, so that it is not easy to distinguish between the intrinsic tone (depth) of the colour and that caused by the fall of the light. For that reason white objects were chosen for our first study of tones.

Look at the colours you painted on your colour wheel, all of them applied at full, almost undiluted strength, and you will see that they range from extremely pale (lemon yellow) to extremely dark (blue-violet). In fact photographed on black and white film and working around clockwise, it would be obvious that the palest colours are at the top, and the darkest at the bottom. Flower painters and all who enjoy working in vivid colour make use of this fact by applying the simple 'maxim': *Move up the wheel to make objects lighter, and down the wheel to darken.* The three examples on this page demonstrate how this maxim is applied.

▲ APPLE

Three colours – orange, bright red and wine red – have been applied wet-in-wet, with the lightest colour at the top and the darkest at the bottom, resulting in the appearance of form without any loss of colour saturation.

▲ VIOLET JUG

Red-violet has been used for the light area and blue-violet for the shadows. I do not mean to imply that both colours were equally dilute, when clearly the red-violet was more so than the blue-violet. But it is true that both the stronger mixture and the blue content have contributed to the effect of shadow, which conforms to the accepted perception that shadows are cooler than lighted areas.

▲ TREE

Although the colours used are natural olive greens rather than pure vivid greens, it has still been possible to apply the same maxim and use yellow-green at the top and blue-green below.

Project:

Using colour and tone together to create form

I chose this subject because it gives the opportunity to use many different colours as well as Cézanne's 'forms of nature'. (Note the cylindrical form of the doll's limbs, the shortened cone used for the bucket, and the cuboid shapes of the alphabet block and the toy car.)

Collect, arrange and draw similar objects on watercolour paper, working any size you choose, and paint in the direct method, working some areas wet-in-wet as appropriate. Use both ways of creating shadow and form discussed to date. Mix washes that are both more dilute and higher up the colour wheel for areas catching most light. Use stronger and cooler versions of the same colours for areas in shadow. Feel free to superimpose washes of blue or blue-grey to strengthen the shadows wherever you wish to increase the illusion of the form of the objects.

▲ NURSERY STILL LIFE

Using brushmarks to create the illusion of form

Brushmarks, like pencil marks, can be used to serve different purposes. Multi-directional brushmarks, applied with verve and at speed, lend a sense of excitement to a painting, whereas smooth-flowing washes engender a feeling of calm. Those works where the paint has been applied in brushmarks alone, with many tiny white gaps between the colours, seem to be full of sparkle and light. Brushmarks can also contribute to the illusion of space and distance. To hammer this message home to students I often find myself saying: 'Painting is not just filling in shapes with colour. That's garage door painting. Make the brushmarks say something.'

The examples here show three ways in which to apply colour to an orange, in both coloured pencil and in watercolour. You will find it easier to use coloured pencils first if you wish to try this for yourself. Then repeat the exercise in watercolour, first laying a flat disc of orange, and then superimposing your brushmarks.

Tip

As a way of 'rehearsing' what brushmarks you might like to use in a painting, you could first try making a small study using coloured pencils or Neocolor crayons. Again leave tiny gaps in order to prevent colours blending together.

▲ LINES
Uniform vertical or horizontal pencil marks emphasize the flatness of a shape, even when using varying colour tones to suggest form. This style of application could be used in works where the decorative element is more important than three-dimensional illusion.

▲ DOTS
Here colour has been dotted onto the surface to suggest the pitted surface texture of orange skin.

▲ CIRCULAR LINES
Pencil marks have been applied in a circular fashion, following the form of the orange. Compare the sense of roundness here with the other two pencilled examples.

▲ FLAT WASHES
A variegated wash (one in which two or more colours are applied wet-in-wet) has been applied to the orange. Only the tonality – darker tones below, lighter above – suggest the form. This is not quite as flat as a disc of uniform colour, but it could be further enhanced with brushmarks (see far right).

▲ DOTS OF PAINT
After applying a variegated wash and allowing it to dry, dots of colour have been superimposed in imitation of the fruit's pitted skin. This method of application will appeal to those who enjoy *trompe l'oeil* painting – painting which 'deceives the eye'.

▲ CURVED BRUSHMARKS
A few brushmarks which follow the rounded form of the fruit have been superimposed over the dry, variegated wash.

Project:

Using brushmarks to create form in a landscape

Working *in situ* or from your own sketches and photographs, draw the main outline shapes of your chosen landscape on watercolour paper, using an HB or B pencil.

For the painting, two approaches are possible. You could apply flat washes of colour in the direct manner, and allow to dry. Then superimpose shadow areas using brushmarks which follow the forms. On the hills and mountains these should describe the slopes, clefts and crags. In the foreground do not be tempted to use marks to suggest the texture of grass, but continue to show the undulations in the land. Curving marks applied as shadows on the trees will give them rounded forms, while vertical or horizontal marks on buildings should add emphasis to their solid, rectilinear structures.

Alternatively, you could apply all the paint in a series of brushmarks, making use of tiny gaps so that the colours cannot run together and form washes. Aim to use the right colour and tone for every mark so that no superimposing is necessary.

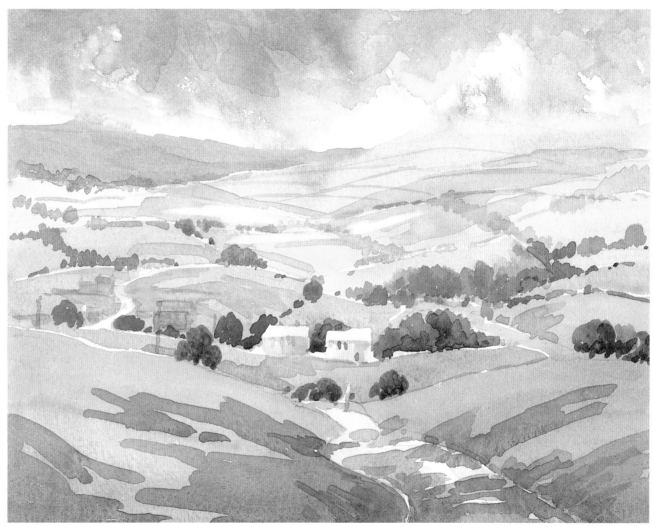

▲ MOOR LANE – PASSING SHOWERS

The illusion of space

We need to remind ourselves that all art is illusion – it is no more than paint applied to a flat surface. Think of Rennaisance paintings with figures and little cherubs, apparently peeping down on us from the ceiling, or Dutch interiors where we see through doorways, down corridors and into further rooms beyond. Such convincing illusions! We have perhaps become too accustomed to the illusion of distance and space in Western art so that we are unable to analyse how it is achieved.

Most obviously it can be created with the illusion of perspective – by making objects in the distance smaller and higher on the picture plane than similar objects closer to us. Less obviously, skilful use of tone, colour and brushmark, and the amount of detail and degree of sharp focus, all have a part to play, and we can choose which of these contributory factors are most appropriate to our chosen subject.

As usual we shall look at the ways

Aim

■ To create a convincing illusion of space by means of tone and colour, and the use of detail and definition

of creating an illusion of space one by one, so we understand and remember them.

Using tone to create the illusion of space

Using a greater range of more sharply contrasted tones in the foreground, and paler, less contrasted tones in the distance, makes perhaps the most significant contribution to the illusion of distance. For this reason I, in common with most artists, always make a small tone study before starting to paint a landscape. Such studies are usually referred to as 'compositional' studies – which they undoubtedly are, though the term does blind us to their importance in ensuring depth in the painting to come.

Exercise:
Making a tonal study

Try it out for yourself. Create a strip of pencil scribble on paper like the one shown here, making pale greys at the top, gradually increasing the tonal range in the middle, and ending with a full range of tones – white, black and greys – at the bottom. If you have worked effectively,

when you view this strip upside-down the top – ie the area of greatest contrasts – will appear to topple forwards towards you, proving that areas of contrast do in fact appear to be nearer than areas of less contrasted and paler tones.

Now make a small tone study for a landscape using any fairly simple image you wish, but with the strip you have made fastened to your drawing board alongside the study you are creating. Make constant reference to the strip to ensure that you are not straying from the scribbled tonal range.

Project:

Painting a monochromatic landscape

The previous tonal pencil study can now be translated into a watercolour painting. This is an opportunity to make a painting using two almost complementary colours: a cold blue (in my example, Winsor blue); and an impure red-orange (burnt sienna). (It may not be strictly accurate to call this a monochromatic – single-colour – painting because if the blue colour predominates, the mixes will be an impure blue-green, whereas with the proportions reversed the effect will be similar to an old-fashioned sepia photograph. However, try to balance, in so far as is possible, the two colours the same way throughout.)

Painted in the direct method – that is, starting at the top and working one area at a time – gives the opportunity to practise subtle degrees of tinting. Working from your own pencil study (or mine, opposite), begin by painting the sky in the palest possible wash. For the distant hills the mix should be a little stronger, and for the trees stronger still. Take care, however, to save your 'big guns' for the foreground where there should be some areas of white paper, some patches that

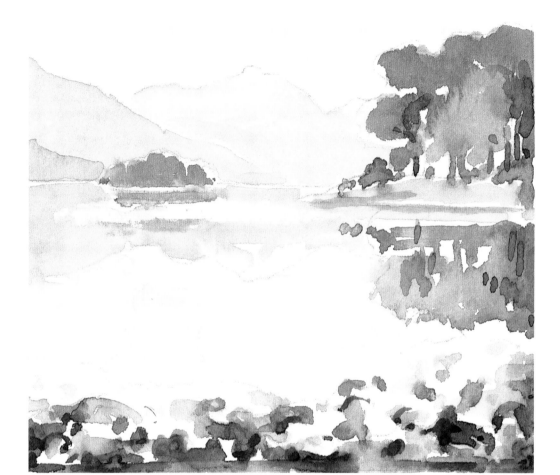

▲ MONOCHROMATIC LANDSCAPE

are extremely dark, and some that lie between these two extremes. In other words, it is a mistake to believe that if foregrounds are to appear to advance they should always be black. A wide range of tones gives an even greater effect of nearness.

Using colour to create the illusion of space

In order to use colour effectively in suggesting space and depth, it is necessary to remember the following principles:

■ Colour temperature: warm colours advance, cool colours recede.

■ Colour purity: pure colours advance, less pure colours recede.

■ Colour variety: the distinction between colours decreases the further into the distance you look.

Colour temperature

In a famous quotation taken from one of A. E. Housman's poems, the poet, speaking of lost contentment, recalls 'those blue remembered hills'. It's a telling phrase because surely we all have memories of such a landscape – but have you ever walked on a *blue* hillside? No, of course not: when you arrive there the hills are covered with the usual green grass, grey rocks or white snow. We might remember Housman's words, however, should we ever have cause to complain about the apparent flatness of our paintings.

This observable blue effect is something we can exploit to enhance the illusion of space and distance, but it would be altogether too simplistic to suggest that all the distant parts of landscape should be rendered blue. In painting all judgements are comparative, so a painting may be entirely green; however, with cool blue-greens in the distance and warmer yellow- or olive greens in the foreground, we are still making use of the notion that warm colours appear to advance while cool ones recede.

Colour purity

This is another aspect of colour and recession. Just as warm colours appear to advance in comparison with cooler ones. so also pure colours in a painting appear to be nearer when compared to less pure, more neutral ones. For example, imagine a row of brightly coloured beach huts. The blue ones would appear to be cooler and more grey-blue in the distance.

Colour variety

Because of the two principles above, it is observable in any landscape that there is a greater diversity of colours near you, and much less variety as you look into the distance.

Colour in different subjects

Although I have been applying all the above to landscape subjects, the same principles can be applied to subjects of more limited spatial depth such as gardens, or even flower and still-life works. Using less vivid and cooler coloured flowers between and behind stronger blooms is a great way to create the illusion of depth, as I hope my example demonstrates.

▼ WILD FLOWER GARDEN

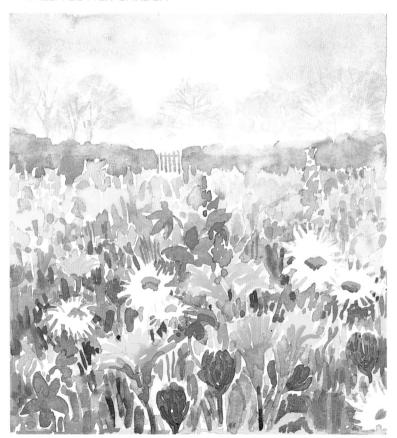

Project:

Creating the illusion of space using colour alone

Choose a landscape image with good depth of field: distance, middle ground and foreground.

To ensure you do not accidentally cheat by using tone as well as colour for this project, before you begin it would be wise to make a colour strip starting with the coolest and least vivid colours at the top. Work in coloured pencils or little dabs of watercolour paint. This is more difficult than you might suppose, but do your best to keep the tonality the same throughout. In other words, if the strip were to be photographed on black and white film, a uniform grey would be all there was to see. As you work down the strip, gradually increase the colour temperature, purity and variety without in any way strengthening the tones.

Next make an outline drawing on your watercolour paper and pin your colour strip alongside it on the drawing board. When painting the distant areas, use only those colours at the top of your strip, and so on to the bottom. The lack of tonal contrast will produce an unusual effect, perhaps reminiscent of morning light, and evoking quiet and calm.

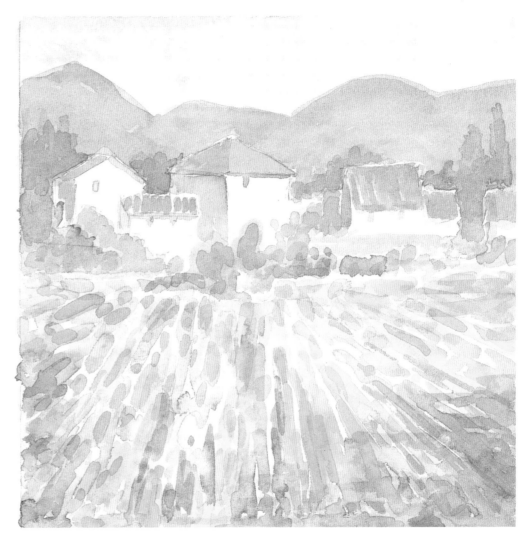

▲ PROVENÇAL LANDSCAPE

Using detail and definition to create the illusion of space

If you visit a watercolour exhibition or take out a selection of illustrated books from the library, you cannot fail to notice how very differently artists interpret the world around them. These different interpretations are sometimes referred to as painters' 'style'. Style is not normally deliberately chosen or adopted: it just develops, in much the same way that handwriting does. Undoubtedly your style will have been influenced by paintings that you have seen and admired, but for the most part it will have grown through practical experience.

The readers of this book will be working in many different styles on a scale from extremely loose, free and impressionistic, to precise and carefully delineated; some will be closer to one end than the other, while others will feel that they are somewhere in between. For this reason it is not for teachers to say that this or that is the correct way to paint a distant tree, or to make one appear closer to you, and so on. As a general principle, however, it can be confidently stated that objects given more detail and definition will appear to advance in comparison with those that are less detailed and distinct.

Exercise:

Using different degrees of detail and definition to enhance spatial illusion

Try painting the same object several times using different degrees of detail and definition. You will find it impossible to keep tonal contrast out of the equation, but try to keep the colours similar and the objects more or less the same size so that it is mainly your manner of interpretation which creates the illusion of distance. Then ask a friend which of your trees (or buildings or people, etc.) looks nearest, and which look further away. Experiment with working on damp paper and painting wet-in-wet to achieve softer and more 'distant' effects.

Project:

Painting a landscape which includes water

For this project I suggest you choose a subject which includes water – as it is not easy to give the surface of water the illusion of distance which can result in works where the land appears to recede, while the water resembles a vertical wall! Ripples and other movements in water are visible close by and can be conveyed with brushmarks, but these should diminish and eventually disappear altogether in the distance.

It is difficult but not impossible to paint a watercolour consisting entirely of brushmarks (see some of Cézanne's watercolours), but where brushmarks are used, be sure to make them smaller, less tonally contrasted and less defined in the more distant parts of the painting. Also, try not to depend too heavily on tonal contrast and colour temperature for this work. In the next project we shall be looking at whether all methods should be combined in every work, and if not, what choices can be made.

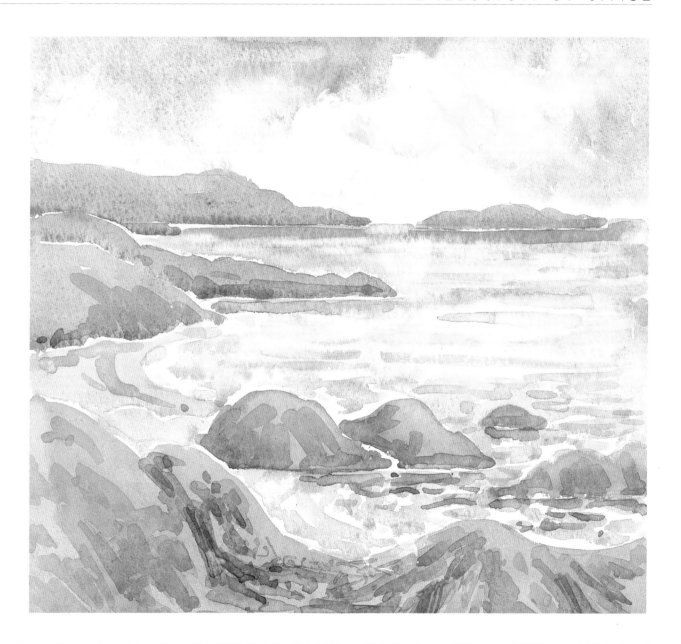

▶ **THE TURN OF THE TIDE**

Three-dimensional form and space – putting it all together

In my introduction I said that, in the early stages of learning, the aspiring painter has a new language to learn – a new understanding of such words as line and shape, tone, texture and colour. It is in these terms that we have been analysing and learning how to create the illusion of form and space on what, I must repeat, is no more than flat paper.

Having examined the means by which we create this illusion separately and in some detail, you may now be wondering whether all these conventions must be applied to every painting. In fact, I doubt whether that would be possible, nor do I think it would be desirable.

Conflicting aims

Sometimes the methods of creating the illusion of space conflict with other objectives. For example, if your intention is to create a soft, romantic impression or to convey a misty day, strong tonal contrasts would be counter-productive. You would have to try other ways of creating the illusion of distance – perhaps warmer colours in the foreground.

In another example, in which a strong focal point such as a bridge or a building in the middle ground is important to the composition, clear delineation, contrasting

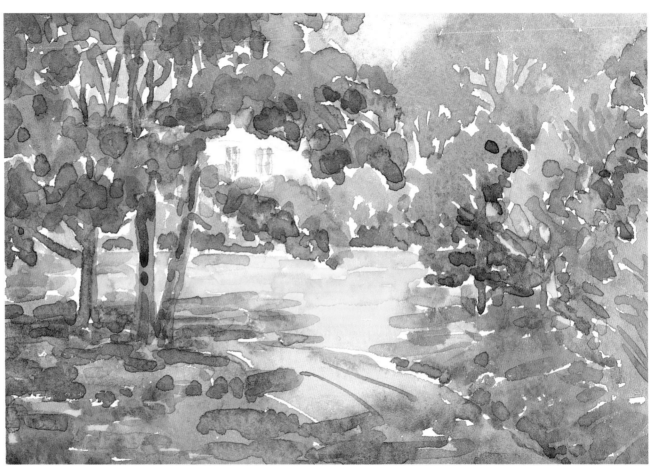

tones or bright colours might all have been used to draw the eye to this feature, reducing the effect of distance. Here, some descriptive brushmarks in the foreground could help to maintain the illusion of depth without detracting from the main area of focus.

▲ SUNSHINE ON THE LAWN
In this colour study it was the vivid colour of the splash of sunshine on the grass that caught my eye, but I hope that the illusion of space has been maintained through the use of warmer and more varied colours and textured brushmarks in the foreground trees.

Project:

Painting a landscape demonstrating the illusion of form and space

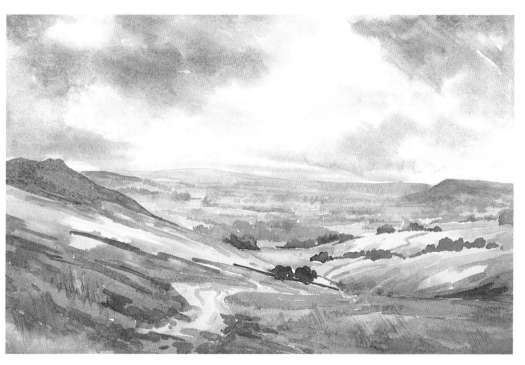

Choose a landscape with plenty of depth. Make a tonal study in soft pencil or monochrome washes like those on pages 54 and 55. Next make a colour temperature/purity strip similar to that on page 57. In this case, though, make no attempt to exclude tonality from the colours, but use colour as you intend to use it in the painting.

With your tonal study and colour strip in view, draw the outlines onto the watercolour paper and paint the landscape in the direct method (see page 13), working from the top of the painting downwards. Don't forget to use the brushmarks to give form to the hills and trees in your picture.

SECTION TWO

Making beautiful images

◀ HARBOUR
SCENE
The more
convincing the
illusion of reality in
a painting, the more
difficult it is to see
and think of it as
an arrangement of
lines, shapes, tones,
colours and
textures. In this
scene, however,
these abstract
qualities are more
readily identified
because the sky,
hill, houses and
boats are so
stylized as to be
hardly recognizable
as such.

Perhaps you have worked slowly and systematically through every project in Section One, or perhaps you felt able to identify particular problem areas and consequently were able to pick out the relevant exercises and projects.

Whatever the route by which you arrived at this point, I hope that you are now accustomed to laying out your palette in colour wheel sequence, and feel greater confidence in your ability to mix colour. Facility with drawing does demand constant practice and few of us would claim to be fully satisfied in this respect. However, regular practice, coupled with the very specific ways of looking laid out in Lessons Two and Three, will ensure continued progress, so carry a sketchbook with you and take every available opportunity to draw. In addition, you could – as some of my students decided to do – copy the checklist on page 61 into the front cover of your sketchbook to help you create convincing images of solid objects in real space. In the early stages of learning all this takes time and conscious effort, but it does become easier and eventually mostly automatic.

Aesthetic considerations

In spite of every effort to focus single-mindedly on each of the essential aspects of representational picture-making in turn, I am sure you shared with me the constant hope that every project would produce a beautiful painting as well. In short, it takes no time at all to realize that convincing images alone do not satisfy if they are not also pleasing to the eye.

What constitutes a pleasing painting? Is it possible to analyse beauty, or is it true that 'beauty lies in the eye of the beholder' – that it is something so peculiar to each individual's taste that it defies analysis? Of course we do have individual preferences. Yet in spite of such individual likes and dislikes I believe there is some common ground in what is held to be aesthetically pleasing, and it is this common ground that we are going to explore next.

To begin with, in Lesson Six, we shall look at composition and some different ways of designing a painting. Lesson Seven is devoted to some of the many and various ways of using colour in painting. Finally, in Lesson Eight, we shall consider the importance of the intrinsic beauty of paint itself.

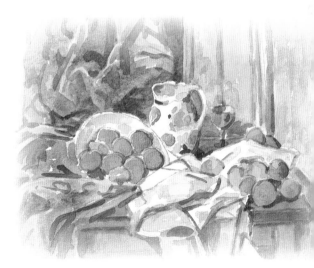

Composition

'The whole effect of my painting depends on composition,' said Matisse. According to my dictionary to compose is 'to put together or arrange parts', and in painting I would say it is the bringing together of the separate elements of a work into a cohesive and pleasing whole. One could think of the composition of a picture as being its underlying structure or its basic design, and I have no doubt that good composition should be our first priority in every painting, regardless of subject, medium or style. Unfortunately it is easy

Aims

- To emphasize the vital significance of good composition in successful painting
- To explain the basic principles of composition
- To encourage the study of composition in masterworks
- To explain why compositional planning is especially important for watercolourists
- To encourage some form of compositional planning prior to painting
- To foster the creation of aesthetically pleasing pictures which exploit the beauty of the watercolour medium

to be blinded to the significance of composition when the painter's skill in creating the illusion of reality, and the beauty of the chosen subject, are often so convincing and beguiling.

We have already touched on the subject of composition in Lesson Three when considering the importance of negative shapes in painting. I suggested then that the composition of many paintings could be improved by the use of L-shapes and some judicious cropping. This is indeed a useful strategy, but can we find out more about what constitutes good composition, and how we can achieve it?

I believe that a painting with good composition will make an immediate impact, and that it will continue to hold and sustain the viewer's interest, and I believe it will do this through a combination of both unity and diversity.

Unity and diversity

The harmony or unity of a work may be the result of a limited range of similar colours (for example, the warm colours used in the painting on page 47) or of tones; or it may be established through the repetition of a shape echoed many times, as in Cézanne's still-life paintings.

However, if the work is all harmony with no contrast it will seem boring, and will not hold our attention for long. The painting on page 57, for example, has an almost total lack of tonal contrast; this is offset, however, by the diversity of colour.

Exercise:

Composing abstract shapes

This is a good way to concentrate on composition alone without the need to produce a recognizable and convincing image. You will need some squares of black, white and grey paper for the first exercise – you could use small pieces of sugar paper. For the exercises with colour you could collect cuttings from colour supplements or buy a packet of coloured gummed squares.

◄ RECTILINEAR SHAPES
Cut out some rectilinear shapes in black and grey paper. Arrange the shapes on white drawing paper (A4 or A5), allowing them to overlap wherever you wish. Harmony is established by using only straight-edged shapes, while the three tones give a degree of contrast. In laying out your arrangement, be guided by your intuition. If it looks pleasing to you, then it is 'right'.

◄ CURVILINEAR SHAPES
Do a second composition, this time using both curvilinear and rectilinear shapes in black, white and grey. The increased range of shapes gives greater diversity and will perhaps yield a more interesting design than your first effort.

▼ MIXED SHAPES AND COLOURS
Broaden your efforts by using a number of different shapes in a variety of colours. A full range of colours and shapes is, however, almost certain to end in a confusing muddle. To avoid total chaos, you should impose some limitation either to the number of colours used, or by confining yourself to a single shape repeated in different sizes and placed at different angles.

Project:

Producing a painting from a paper collage

Create a painting based on one of your paper collage designs. The application of paint will add the new element of texture to the design via brushmarks and variegated washes.

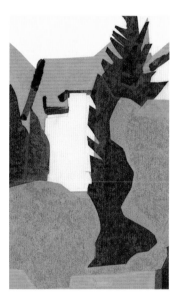

▲ TOWARDS THE FIGURATIVE
Use papers in three or four tones to create a composition based on sketches of a real place. The method ensures simplification of the view into main tonal masses. Use L-shapes to check if the design needs cropping.

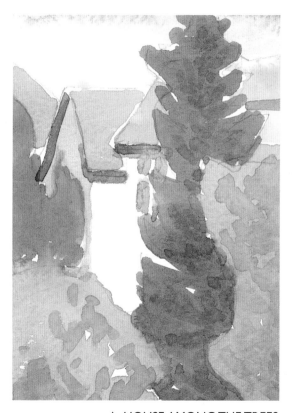

▲ HOUSE AMONG THE TREES PAINTING BASED ON PAPER COLLAGE
The colours are faithful to the tones of the collage.

Learning from the masters

Over the years I have come to appreciate how fortunate I was with my school art teacher. Week by week we were asked to spend a little time copying the compositions of great works. From quite small reproductions we had to seek out the structure of lines and shapes and tonal masses, and to write a few words saying what we had learnt. To this day I remember discovering how, through the positioning of arms, hands and faces, Hogarth led the eye around and through one of his paintings, something I doubt I would have noticed by just looking.

As a teacher myself many years later, I set students to do a similar exercise with some of the still life paintings of Cézanne, resulting in many surprising discoveries. How carelessly the objects appear to be scattered on a table among drapery apparently thrown down at random! But our efforts to copy his paintings revealed that nothing was careless or random – on the contrary, everything had been deliberately placed, the separate parts all locking together into a cohesive and structured whole.

Studying Cézanne

Any work by Cézanne would make a good starting point for a study of composition in masterworks. In his well known *The Card Players*, for example, notice how he links the seated figures with a series of V-shapes along their shoulders, which is repeated in the legs beneath the table. Among his landscapes, I love *Château at Medan* for the meshing together of many verticals and horizontals all overlaid with diagonal brushmarks.

▶ **STILL LIFE BY CÉZANNE**

Before attempting my watercolour version of Cézanne's *Still Life with Faïence Pot*, I drew this diagram showing how many of the lines in his composition converge on a small and seemingly insignificant piece of fruit near the back right-hand corner of the table. In addition to the repeated rounded forms of the fruit, how many of the less obvious triangular shapes can you see? Even a cursory glance will reveal at least a dozen. Repeated shapes and lines give rhythm as well as cohesion to a painting. Having analysed the composition of the still life, I then produced my own copy. When transcribing from oil painting into watercolour as I have done here, the overall effect will probably be paler than the original. Cézanne's watercolours consist largely of brushmarks, and I have tried to imitate this technique in my interpretation.

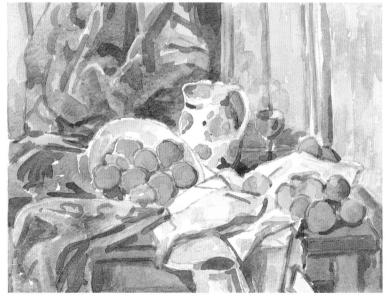

Cotman and Whistler

Don't neglect other painters, both the Old Masters and more contemporary artists. It is especially instructive to study the composition of tonal masses in works by John Sell Cotman and James Whistler. In Cotman's work it is the distribution of the tones – the way he set light against dark, dark against light – which fascinates. Whistler, too, was concerned with tonal masses, and makes his priority clear by naming the famous portrait of his mother *Arrangement in Grey and Black.*

◄ TONAL MASSES
This study based on Whistler's *Arrangement in Grey and Black* reveals the importance he placed on the balance of tonal masses in the composition, and how both the positive and negative shapes relate to the picture's format.

Exercise:
Copying a masterwork

For this exercise, try to work A4 or larger. You may be able to find large reproductions of masterworks in a calendar. Failing this, I suggest a visit to the local library. A book can be protected from paint splashes by sliding it into a transparent plastic cover and propping it up on a book-stand.

Before taking these precautions, however, first make a line/shape drawing freehand or using tracing paper. If this is done with the lightest possible pressure on the pencil there is no risk of damaging the book. With the tracing or drawing complete, try to be aware of the underlying structure of the composition – which is, above all, the purpose of the exercise. It is important to make an accurate drawing if you are to discover the 'hidden' composition of the work.

You can make the tracing paper act as carbon paper by scribbling on the back with a soft pencil. When you have done this, lay the tracing on top of the watercolour paper and go over the outlines of the drawing once more with an HB pencil to transfer it to the paper below; then complete your painting.

Tip

There is a transfer paper for artists, available in five colours of which the 'graphite' or black is closest to pencil in appearance and which can be erased in just the same way. First make your tracing, then slip the transfer paper between the tracing and the watercolour paper and go over the outlines with an HB pencil.

Collecting and arranging still-life subjects

The great advantage of still life painting is that you can work in the comfort of your own home, choosing, arranging and painting; you may even be fortunate enough to be able to leave the objects *in situ* and return to them another day. Nor do you have the problems of changing light or fluctuating weather – not to mention curious passers-by – which you might have to contend with when painting a landscape. Moreover there is no doubt that the relatively shallow spatial depth of still-life painting is much easier for the beginner to cope with than the vast outdoors.

Guidelines for still-life painting

Choosing objects

■ Visit galleries and see if you can find ideas and inspiration for the subject, perhaps making small sketches of any still lifes that attract you.

■ Find a theme. Many Victorian images come to mind of dead birds and things you might wish to cook with them! These are no longer fashionable, thank goodness, but a still acceptable alternative might be some wine bottles, grapes and wine glasses – see page 29 for a favourite theme of mine: coloured glass objects standing on mirror tiles. With their reflecting surfaces, glass, silver and brass present a real challenge. For beginners, a garden theme including, say, earthenware pots, a trowel and some plants or flowers, offers interesting shapes, colours and textures. Or you might prefer to take a close look around your home.

■ Consider unity and diversity. Avoid objects which are too disparate in style or function, which you would neither wish nor expect to see together, such as a crude earthenware pot with a dainty Dresden figurine. Similar shapes or harmonious colours will unify, while objects of different height or scale, colour or tone will add diversity and interest.

Arranging objects

■ Consider the height of the table on which you are going to set up your still life; if it is too high you will find it difficult to give the composition depth. Looking down on the arrangement is more interesting, but a *very* low arrangement can be difficult to draw.

■ Set the arrangement against a wall or in a corner so that you can include drapery or other features behind it. These, like the negative shapes, will have equal importance in the overall design to the objects themselves.

■ Think about the lighting. Natural light from a north-facing window is the most constant, but many prefer to work in artificial light which can be guaranteed not to change at all. A single light source from one side simplifies the shadows and helps define the forms, so an adjustable lamp can be really useful. Don't forget that you need light on your paper, too.

■ Look at the base line of each object (see pencil study). The different levels show that some objects are near and others further away. This, together with some overlapping shapes, gives depth.

■ Move the objects around just as you would when arranging furniture and ornaments in a room. This is intuitive decision-making: when it looks right, it is right.

■ Use a viewfinder to help you envisage the overall effect, holding it near your eye to frame a large area, further away for a smaller one.

■ When you are reasonably satisfied with your arrangement, make a small rough sketch, adding hatching for the tones. If the sketch does not satisfy you, either make changes to the arrangement or try a completely different viewpoint.

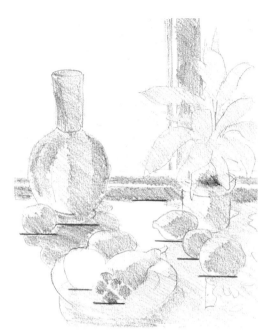

▲ STILL-LIFE STUDY

Doing a little tonal sketch like this helps you to envisage the painting but it does not guarantee a successful outcome. However, with the composition largely resolved, you can then concentrate on other important considerations.

Project:

Painting a still life

First be sure that the watercolour paper and your pencil sketch are of the same proportions. If copying the outlines onto larger paper is a problem, try quartering both sketch and watercolour paper with very faint pencil lines, and copy from quarter to quarter. Alternatively, try another drawing on cartridge paper, working the same size as you intend to paint and turning the cartridge into 'carbon' paper as you did with the tracing on page 67.

Assuming that you gave thought to a pleasing colour scheme when choosing your objects and their setting, all that remains is to apply the paint. Mix the colour, and transcribe what you see into washes and brushmarks, keeping the paint fresh and transparent. My one golden rule for beautiful transparent paint is: *do not work on paint that is neither wet nor completely dry.* By all means feed extra colour or water into wet areas, or superimpose extra layers or brushmarks on absolutely dry earlier washes, and lift paint from either wet or dry areas – but don't fiddle about with almost-dry paint! To do so, in my opinion, is the biggest single contributor to unpleasant, muddy-looking paintings.

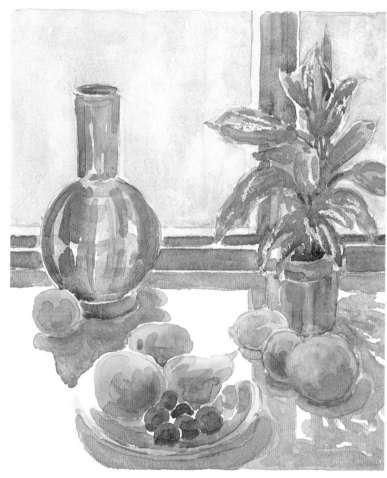

▲ STILL LIFE WITH FRUIT AND POT PLANT

Landscape composition

For the previous project we arrived at the composition by choosing and arranging objects, and when reasonably satisfied, tested the proposed painting by making a small tonal sketch. If the sketch did not inspire confidence there were two options: to rearrange the objects or to try a different viewpoint.

In landscape a complete rearrangement of the different elements is neither possible nor desirable, although taking some artistic license is (see pages 72–3). If, like me, you have spent hours searching for a perfect view, then you will know that such a thing scarcely exists, and that in the end one has to settle for something with potential and do one's best with it.

Time and again I see beginner painters set up the easel and 'dive' in, with little more than a cursory glance through a viewfinder. If you are working in a medium such as oils or acrylics, both of which offer endless opportunity for correction and adjustments, this spontaneous approach is exciting and creative; but in the unforgiving medium of watercolour it seems positively to invite failure. Professional painters, by contrast, normally prefer to spend time exploring their subject with a series of studies before attempting to paint (see right).

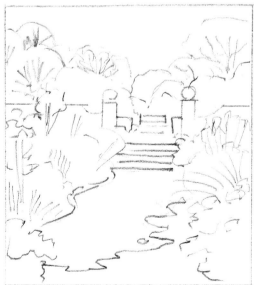

◄ TONAL STUDY
This is a small, simplified black-and-white version of the proposed image. The artist begins by choosing the most pleasing viewpoint, probably using a viewfinder, decides whether to work in a landscape or portrait format, and aims to create a pleasing arrangement of the main tonal masses in a balanced but not too symmetric way – quite possibly also bearing in mind the principles of the Golden Section (see next page). Hopefully, the study also demonstrates the illusion of space.

◄ LINE DRAWING
Some subjects depend heavily on a linear element for their interest, and here a line drawing (or drawings) can be useful. This serves to establish not so much the outlines of the shapes as any hidden rhythms or connecting lines holding the parts together. (Remember the connecting lines in Cézanne's still life.) In addition, a different type of drawing – slow, carefully observed and accurate – especially of any areas you feel might be difficult to cope with, enables an easier transcription into paint. Attempt both types of drawing.

▲ COLOUR NOTES
Colour notes should direct your thoughts towards the overall effect or mood of the proposed painting. A vertical colour strip like the one here also contributes to creating the illusion of distance.

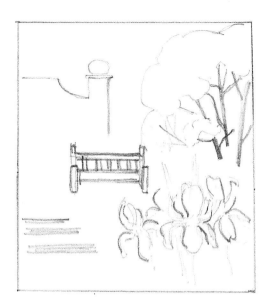

◄ DETAILS
Some careful observational drawing of key details in your composition, in addition to your other studies, familiarizes you with their shapes and provides a useful reference.

The Golden Section

In former times there were many prescribed ways of planning a composition, among which only the Golden Section or Mean is still widely used. This involves the unequal division of a line or area according to a mathematical formula, ⅜ to ⅝, which roughly and more easily can be remembered as a little more than one third to two thirds. It is commonly used to divide a landscape into land and sky, or to place some significant feature or focal point. The diagrams at right are based on this formula and offer four possible 'ideal' areas of focus: two 'ideal' horizon levels, and two 'ideal' positions for placing a strong vertical feature.

◄ CASTLE GARDENS
The finished landscape works better as a cohesive whole because of all the 'unseen' studies produced earlier.

Tip

Even if you were never to refer to your tonal, line and colour studies during the painting process, they help to familiarize you with your subject and will save you from many errors and difficulties in the creation of your painting.

Project:
Painting a landscape

Using any appropriate drawing media, and working *in situ*, make the tonal, pencil and colour studies in your sketchbook, A5 or A4, and then create the painting.

Improving on nature

If every painting which involved the use of artistic licence were to be destroyed, I do believe galleries would be empty. Artistic licence takes many forms. There are painters who took minor liberties such as introducing a few figures to give interest or scale, or who exaggerated light and shade for dramatic effect; at the other extreme, there are those who simplified, rearranged or just ignored individual elements for the sake of the overall concept. Take, for example, Turner's rendition of the river near Bolton Priory, where I often walk. His painting of it includes a bridge downstream, although it is only possible to see both together from a helicopter.

Why do learner painters feel apologetic about taking such liberties when they should be proud of the fact that they put the achievement of a pleasing outcome above all other considerations? After all, a painting is not reality – it is an interpretation in paint. So if nature fails to supply a cloud shadow at just the right moment, or a tree where one would improve the composition, never hesitate to introduce one. If, on the other hand, a wall cuts off the view, simply leave it out. Or perhaps a few clumps of grass would balance the foreground; in this case, draw the clump behind you and introduce it where it is needed.

▶ **CORRECTING THE BALANCE**
Strong diagonals or other unbalanced compositions can often be corrected by introducing a few cloud shapes moving in the opposite direction.

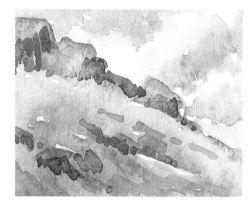

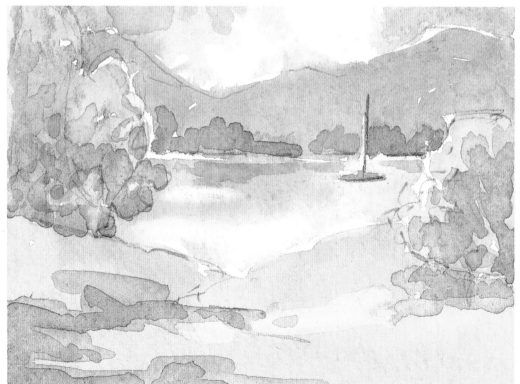

◀ **ADDING A FOCAL POINT**
This scene lacked a focal point and a sense of scale. The addition of one small sailboat supplied both these missing elements. To test whether such a feature would help and exactly where it should be placed, I often cut it out, in silhouette form, and place it on the painting which I have laid on the floor. I can then move the feature around to see where it works best. Figures can be introduced for the same reason and in the same way.

Project:

Painting a landscape using artistic licence

For this project it would be best to work *in situ*, perhaps returning to a subject which in the past has proved difficult to compose. Alternatively, take any location which seems to have potential but is somehow not quite right, and allow yourself the freedom to move or change certain elements for the sake of improving the composition. Experiment with ways of improving on nature by making the tone and line studies suggested on page 70.

In my example the photograph shows how things really are. All the elements I needed were there but not necessarily in the right place. Some trees on the left, out of the frame, were moved in to join the lone tree near the barn. This helps to balance the weight of the larger trees on the right. In the foreground the diagonal line of the little weir took the eye into the bottom right-hand corner and then on and out of the frame. Changed to run diagonally in the opposite direction, it now leads the eye from rocks to the right-hand trees, from where the eye can travel to the barn, the trees on the left and back round to the rocks again, creating a sort of elliptical frame to the centre of interest.

◄ ORIGINAL LANDSCAPE
The photograph shows an exciting subject but one which I felt needed some small changes to improve the composition.

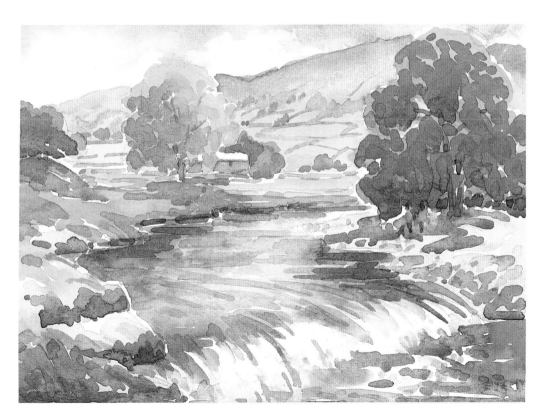

◄ RIVER WHARFE AT KETTLEWELL
Here, the composition has been improved by a few small changes which would probably go unnoticed even by those familiar with the scene.

The creative use of colour

The beginner painter's reluctance to take liberties with reality is very often first overcome in the area of colour, especially when it can be proved that professionals actually choose colour schemes rather than merely mix to match the colours they see around them.

I have a large collection of postcard and calendar reproductions of masterworks which I take to class to make this point. Displayed on a large table, each one married to one of those colour charts you can pick up in DIY stores, they are greeted with amazement by many students. The effect of my display is so startling that one could almost believe that Monet and Van Gogh and many others had had access to these charts! In fact it was Van Gogh who said that he did not mix in order to match the colours around him, but to create harmonious families of colour, so perhaps we should not be surprised.

The chart on this page shows colours copied from these reproductions arranged in colour wheel sequence. Study of the originals will of course be more instructive, but even reproductions are revealing when married to a colour wheel. Some of the colours used are clearly those in one half of the colour wheel, or even just one quarter, while others are based on complementary pairs. It is clear that some schemes were chosen to evoke a particular time of year or hour of day, or to create a sombre, dramatic or romantic mood. The realization that these choices are available to us, too, can be an exciting moment, and opens the door to much greater creativity.

The projects on the following pages offer a selection of creative approaches to the use of colour, and since creative ideas have a way of multiplying, I hope they may inspire you on towards further experimentation.

Aims

- To encourage a more adventurous and less literal use of colour
- To offer suggestions for planning colour schemes
- To encourage experimentation with colour in order to express feelings or to evoke particular times of day, seasons and weather

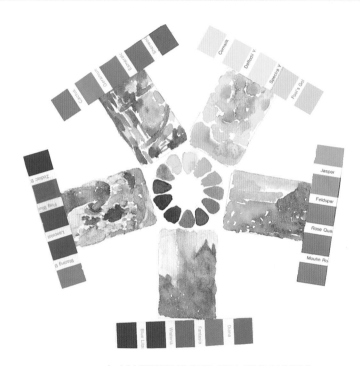

▲ MASTERWORKS COLOUR WHEEL
This 'colour wheel' starts with Van Gogh's almost entirely yellow *Sunflowers* (clockwise from top right) and continues through the orange-reds of one of Monet's *Grain Stacks* and the violets of one of his Rouen Cathedral works, to Renoir's mainly blue *Les Parapluies* (note the touches of complementaries in both these works), and the greens of Cézanne's *Étang des Soeurs*.

Project:

Using colour creatively in backgrounds

If you have never exercised artistic licence with colour, a good place to begin is with the background to a painting of flowers. The first question to ask is: 'Will a coloured background improve the image?' Sometimes white paper is a better foil for flowers than colour. Compare the effects of white and colour by painting two identical flower images with different backgrounds, or paint one with background colour leaving the other as white paper. Which do you prefer?

The image for my two examples was created using only a couple of flowers and painting them from observation, first from one angle and then from another. Thus the composition grew spontaneously on the paper, and when complete, I had to decide what colour, if any, would make the most effective background.

In the larger example the choice was made by holding up various pieces of brightly coloured paper against the painting to find one giving maximum contrast and impact. I have a folder of gummed squares, coloured tissue paper, pages cut from illustrated magazines, and homemade charts of pigments and their tints which I find invaluable for this. Not

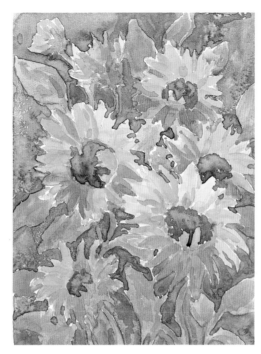

surprisingly the chosen blues and violets are the complementaries of the yellow and orange flowers, while the green leaves complement the touches of red, although I did not think about this until later.

The flowers in the smaller version use the same pure yellows, oranges and reds, while the background consists of *impure* oranges and reds, i.e. browns. (I used burnt sienna, darkened here and there with ultramarine, and lightened by feeding in touches of cadmium orange.) To maintain this harmonious scheme, I had to use more olive greens for the foliage.

The backgrounds in both versions were

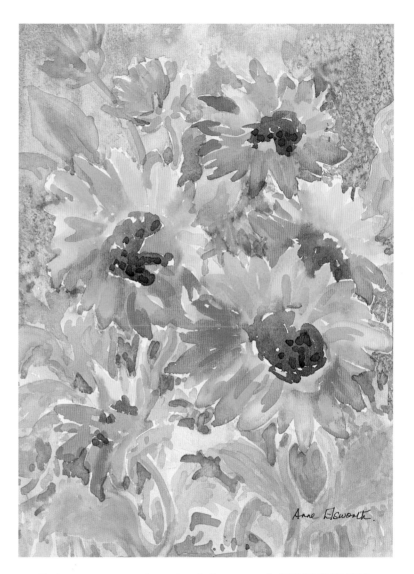

applied one area at a time, that is by painting the negative spaces, and using wet-in-wet techniques.

▲ **REACHING FOR THE SUN**

Using colour for mood, time of day or season

Observation of seasonal changes, and of the changes in light at different times of day, suggests that both tone and colour have a role to play in creating nature's moods. Nowhere is this better exemplified than in the work of the painter Monet. Impressionism came as a considerable shock to Monet's contemporaries, who did not understand why he would choose to paint in such a way. But today he is loved and admired more than any other painter for his portrayal of nature in all her moods, and his ability to evoke particular kinds of weather, the changing seasons and even different times of day is surely second to none. However, it is a mistake to believe that all he did was slavishly copy what he saw. Observation, colour theories, experimentation with paint texture and brushmarks, and much careful planning all played a part – and yet his effects, while achieved through a combination of all these elements, do rely heavily on colour.

The charts on this page give general guidelines as to which tones and colours you could use to suggest particular seasons and times of day. All will, of course, be affected by the degree of cloud cover. However, I hope that they will encourage you to experiment with colour schemes designed to evoke nature's moods.

Seasonal colours

SPRING

SUMMER

AUTUMN

WINTER

Spring
Clear light and new growth. Bright, fresh yellows and greens, and increasing tonal contrast. Skies relatively cool.

Summer
Intense light from a high sun. In northern climes there may still be cool skies, but colours are stronger and tones more contrasted. At summer's end foliage can be very dark. Nearer the equator, pure saturated and warm colours and strong tonal contrasts, warm blue skies.

Autumn
Foliage changes from greens to reds, oranges, and browns, but the sun is lower and skies correspondingly cooler. Colours that are vivid and glowing in sunlight reduced to soft blue-greys on misty days.

Winter
Colours fade to ochres, browns and grey-greens which are stronger in hot climates, paler in cool ones. Snow picks up colour mainly from the sky but also from buildings, or landscape features – a beech hedge before the leaves have gone casts a warm glow onto snow on my lawn. Snow can be seen as tints of warm colours in sunshine, cool blues and mauves in shadow.

Colours to suggest the times of day

The following colours are given on the assumption of fairly clear skies.

Early to mid-morning
Cool colours which are neither saturated nor strong in tonal contrast. However, their warmth, saturation and tonal contrast increase as the sun climbs.

Midday
A strong sun directly overhead gives very little shade, and can have the effect of bleaching out the colours, especially in hot climates. This is normally considered a difficult time of day for painters.

Afternoon
Warm colour and stronger tonal contrast. In the late afternoon as the sun descends, warm colours in sunlit areas contrast with lengthening, cool shadows.

Sunset
Vivid sunsets demand swift colour sketches as the land loses detail, turning to dark masses of tone.

Dusk and night
The range of dark tones with little contrast and cool colours are difficult because of our concern for transparency.

Project:

Using colour to create a mood

I called to see my friend Margaret quite early one morning in June. The sun was still fairly low in the sky and without much heat. All was still and peaceful. I made a drawing on the spot but the painting was executed later in the studio. Having made no colour notes at the time, I felt free to choose those which evoked for me the mood I remembered. They are all tints of relatively pure primaries and secondaries.

Try this for yourself. Take any motif and use colour and tone to create a particular mood or time of day. Working *in situ* you could make monochrome studies such as those described on pages 70 and 71, then execute the painting at home. The colour strip should not be made outdoors from observation, but created by you in accordance with whatever mood you wish to portray. Your tone study will give you the relative values, but depending on the intended mood, you may have to increase or decrease the degree of tone.

A second painting of the same subject using a completely different colour scheme would provide a useful comparison.

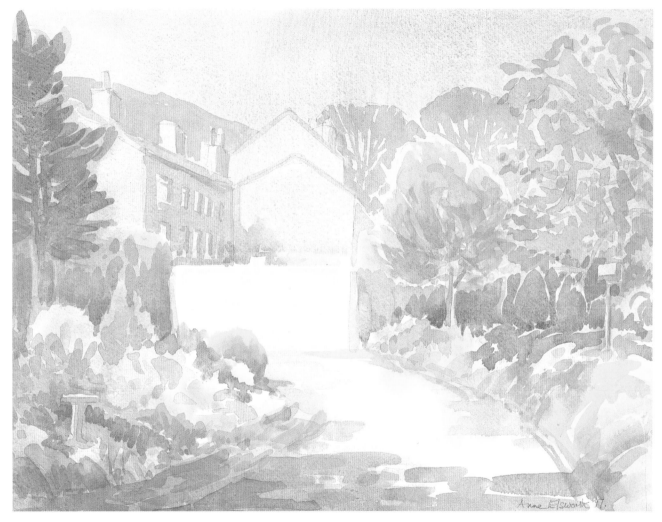

▲ EARLY MORNING – MARGARET'S GARDEN

Project:

Painting a still life using the cool family of colours

This painting uses colours from the cool half of the colour wheel, some at full saturation, others tinted. There are two ways to arrive at a good composition:

■ Collect objects, fabrics, wallpaper samples, gummed paper or tissue squares in cool colours and arrange as described on page 68. Paint what you see.

■ Make a pleasing arrangement of objects regardless of colour. Draw the shapes and ignore the actual colour, but instead apply your chosen colour scheme.

When it comes to applying the paint, you may be tempted to use too little water in order to achieve bright, strong colours, but this could lead to loss of transparency. Instead achieve the desired effect by using as many colours as possible, such as sap green, viridian, ultramarine, cobalt blue, Winsor blue green shade, and blue-violet. Dilute the paint as necessary.

The intensity of colour which this multiplicity of pure pigments creates can be further exploited by breaking up the negative shapes into smaller areas and applying similar colours that are close together on the colour wheel – this is where my packet of brightly coloured paper squares comes in handy.

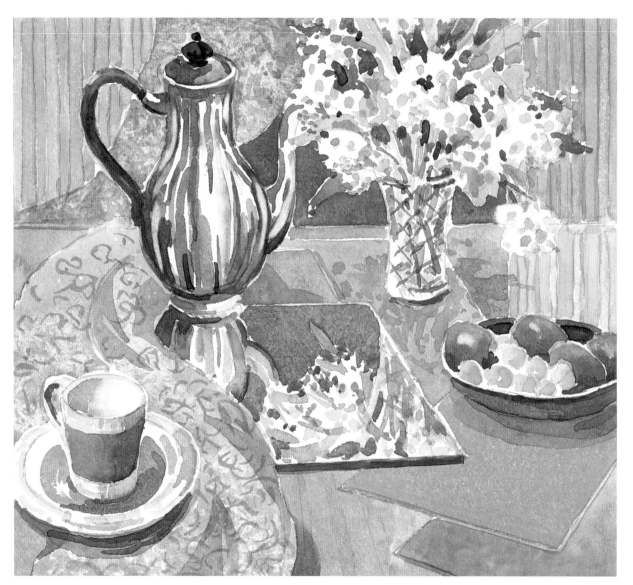

▲ COOL STILL LIFE

Project

Painting a still life using the warm family of colours

This project follows the same principles as the one on the opposite page, this time using the warm colours.

Again, use as many pure colours as possible, starting with lemon yellow, through aureolin, the cadmium yellows, oranges and reds, alizarin crimson, permanent rose and magenta. Allow yourself a little ultramarine to mix with magenta if you lack a red-violet. Combined with a yellow and a red, this blue allowed me to produce the small touches of brown and black needed in my example.

This still life was painted using the colours I saw in front of me, whereas for the cool one opposite the shapes were drawn from life but some of the colours were invented to harmonize with the rest.

The colour wheel can be divided in other ways of course, ways almost too numerous to mention. Our next projects repeat the warm and cool themes but this time using impure mixes. I hope that these, and my other suggestions for using colour creatively will trigger ideas and experiments of your own.

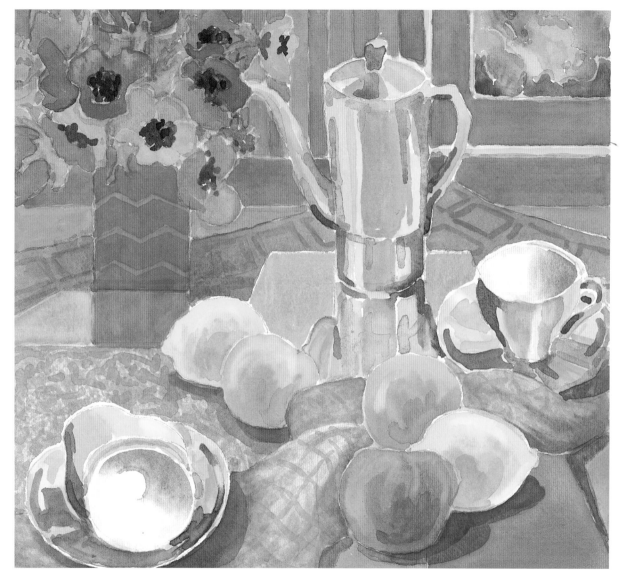

▲ WARM STILL LIFE

Project:

Painting a landscape using the cool family of colours

If you have been remembering to lay out your palette in colour wheel sequence, the rules for mixing less pure secondaries on page 20 will be helpful now. Alternatively just remember that any colour can be rendered less pure and vivid by the addition of a small amount of its complementary colour. These tertiary mixes are illustrated on page 22. For this project, take care to use only those in which blue predominates.

Tinted papers will give you a head start. Choose blue or grey for this cool painting, oatmeal or cream for the warm one opposite. You can, of course, tint white paper with an all-over wash. If you wish to do this, keep the wash pale and let it dry completely before starting to draw the pencil outlines of your subject.

Choose your image, perhaps working from studies as described on page 70. Pay special attention to the tone study because these two projects are heavily dependent on tone for their success.

Apply the paint, using either the direct method (see page 13) and working from the top down, or the layer-on-layer method as shown on pages 44 and 45.

The same image is used for both examples – I hope you agree that such limited colour schemes are extremely harmonious.

▲ COOL LANDSCAPE

Project:

Painting a landscape using the warm family of colours

You might like to try using ready-made impure colours for this project. They offer shortcuts to colour mixing and there are several warm ones available – siennas, umbers and sepias.

In my example I used burnt sienna, introducing small amounts of ultramarine for the dark browns, and raw sienna, again with touches of ultramarine for the earthy greens. For darker greens I had to add a pure yellow since ultramarine and raw sienna can become sludgy in stronger mixes. Tiny touches of the burnt sienna rendered these greens less pure. Had you wished to take similar shortcuts for the project on the facing page, the choice is more limited. Although Payne's grey has a strong blue bias, it would have produced a virtually monochromatic work – terre verte and sepia are other impure pigments albeit with a less obvious cool bias. Alternatively, you could mix complementary pairs to produce tertiaries, this time allowing the reds and yellows to dominate.

The warm tinted papers mentioned opposite might be helpful should you wish to try one, and again, direct or layering methods are both appropriate.

▲ WARM LANDSCAPE

Intensified colour

Many years ago I enjoyed a few painting trips into the countryside with a friend who was a better painter than I shall ever be. I would really have preferred to watch her at work, but feared that this would have been a distraction. Instead I set up my easel nearby and at the end of the day we compared our efforts. What a difference!

Although never garish, her work sang with colour while mine was drab and dull. One day I had the temerity to tell her that although I loved the outcome I simply could not see those colours in the landscape. 'Oh, they are there,' she told me. 'I just exaggerate and make the most of them.' Then she pointed out patches of yellow lichen on what I had taken for a grey roof, and some red rust stains on a barn door. Seeing through her eyes, I began to appreciate that there are very few neutral greys, and that almost all are biased towards some colour – violet, blue or green.

Thereafter I spent a lot of time seeking colour in stone walls and tree trunks and areas of shadow.

Project:

Intensifying realistic colour

Work *in situ*, perhaps at a location which has in the past seemed rather lacking in colour. Use a viewfinder to select the best position, and make a compositional study to ensure that the lines, shapes and tones make a pleasing arrangement.

Before starting to paint, spend some time seeking some colour or colour bias in every area of the landscape. It is important to intensify all colours to the same or similar extent if you are to avoid a disjointed effect. Ideally you should do more than one painting of the same subject, sometimes intensifying slightly and sometimes quite extensively.

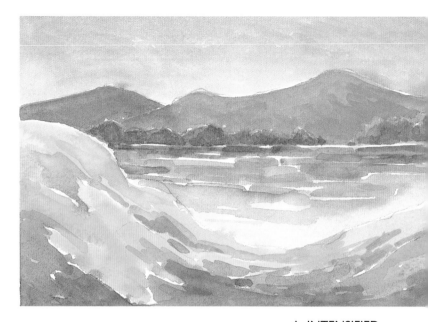

▲ INTENSIFIED COLOUR
The same landscape showing the use of intensified colour.

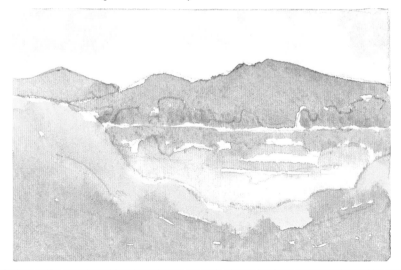

◄ REALISTIC COLOUR
This study shows the landscape in its realistic colours.

Reversing intensified colour

Intensifying the colours as you did for the last project probably produced a recognizable portrayal of the actual place, but in a rather modern way. If you live in a largely cool climate as I do, you may think the outcome was more like a landscape from some equatorial region, although the illusion of space and distance should have remained.

For this project I copied the outlines from the previous one and used the complementaries to the intensified colours on the opposite page. This has the inevitable effect of flattening the image because the cool, receding blues and violets of the background become warm, advancing oranges and yellows. Distant blue-greens are now advancing bright reds, while the foreground yellow-greens become recessive wine reds.

The result of this reversal of colour used for the illusion of distance puts a greater emphasis on the abstract qualities of the painting, by which I mean it becomes more obviously an arrangement of lines, shapes and colours, and less obviously a representation of reality. If your chosen composition was at all weak it is likely to be more obvious this time.

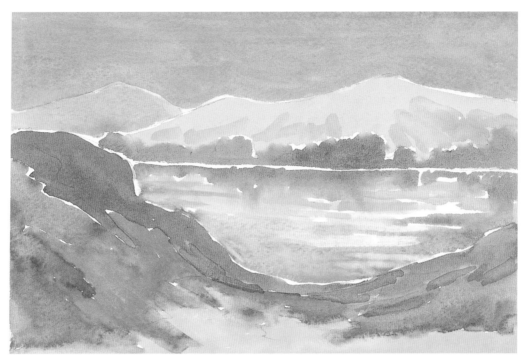

◄ REVERSED COLOUR
In this painting the intensified colours used in the previous landscape have been replaced by their complementaries. This alters both the perception of depth in the painting, and also throws up any weaknesses in the composition.

Project:

Reversing intensified colour

This project involves using the complementaries to intensified colours. I recommend that you work with the same image and have a colour wheel in view for reference. If your chosen subject includes a large foreground area, or strong tonal contrast in the foreground, or any of the other elements which create the illusion of depth, the result will be an interesting conflict between spatial illusion and the flatness of paper.

I hope this project provides some creative fun with colour as well as confirming your appreciation of both spatial illusion and composition.

Celebrating the medium

Have you ever wondered why you paint? It involves a lot of effort, requires a certain outlay on materials and equipment, and especially in the early days, the disappointments do seem to outnumber the successes.

Many would answer the question by saying that they love nature and want to record its beauty and its moods. But a camera does that, too. Others would say their reasons are to do with self-expression and creativity – but writing poetry might be an easier alternative, and you only need one pen and a notepad!

I paint for both those reasons and also because the activity engages and stretches me – but above all I paint because paint itself is beautiful. I just love it! What is more, I love all kinds of paint. If people ask me, as they sometimes do, 'Which is your favourite medium?', my honest answer is, 'Whatever I have in my hand today.'

In my *Watercolour Workbook*, I constantly stressed that beautiful paint should take precedence over all other considerations. This is hard to accept, however, and in spite of ourselves we work too long trying to produce more convincing images, all the while making the paint muddier and less beautiful. The paintings which inspire and move me most usually have the three following elements in common; they combine an arresting image with a feeling, emotion or a universal truth, expressed in such a way that celebrates the intrinsic beauty of the chosen medium. The projects and exercises in this lesson are designed to help you to explore, exploit and celebrate the inherent beauty of watercolour.

Aims

- To emphasize the appreciation of the intrinsic beauty of different media, regardless of image
- To suggest ways of exploiting the beauty of the watercolour medium
- To encourage an interpretative, rather than a literal transcription into paint

◄ OILS
When I am working in oils I do believe I love them best – they are so rich and glossy and 'squidgey', with all that potential for pressing one colour into another while still wet.

◄ PASTELS
The next day I might have my pastels out. Their immediacy is a delight. Picking up each stick in turn and without need for a palette, I can put the chalk directly onto the surface. They combine drawing and painting in a way that is quite unique: first I draw a little with the end of the chalk, then use the side to paint, then use the end again to add marks and lines, and so on.

◄ ACRYLICS
On another day I might paint with acrylics, sometimes treating them much like oil paint, sometimes working in layered washes as with watercolour, and often making minor adjustments with transparent washes over opaque, impasto (thickly applied) paint. The ease of correction with all three methods enables me to take risks and be altogether more creative.

Exercise:

Exploring the qualities of paint

Take a piece of paper and try to discover what it is about watercolour paint that delights you. Work fairly large and move your arms about freely. Use large brushes. Put some music on perhaps, and paint expressively as the music suggests. With the paper almost vertical, paint will run and dribble; with it flat, colours will blend and bleed together. Try causing a backrun (a cauliflower-like blotch) by dropping water onto almost dry paint; use a toothbrush to splatter strong colour into a pale, wet wash; apply paint with a sponge or your fingers; or draw into a wet wash area with the end of your brush. Paint like a child for the sheer enjoyment of doing it. Go on – I dare you!

▲ WATERCOLOURS

Then I take up the watercolour challenge again, and there is nothing to compare with their glowing transparency, the way the colours run and bleed and blend together in random backruns and happy accidents. With watercolour I learn to work quickly in order to capture the moment, and to simplify because least says most.

▶ **LIFTING OFF**
Wet paint was lifted off with folded blotting paper.

▶ **BACKRUN**
A backrun was created by dropping water into a partially dry wash.

◀ **SPLATTER**
Strong mixes were splattered onto dry paper (at left) and damp paper (at right).

Experimental techniques

So far in this book we have used the conventional techniques of the medium, working in both the direct and layer-on-layer methods, and in some areas we have used wet-in-wet techniques. However, we have not yet tackled working on paper which is wet or damp all over, nor have we made use of the many special effects which are possible with water-based paint. Since this chapter is about celebrating the medium to its full potential, it would be a good idea to try a few exercises first, before proceeding on to the projects.

Wet-in-wet washes and lifting techniques

Wet the paper all over with clean water using a sponge or a large brush. Then apply two or three ready-prepared mixes, working from the top down and allowing the different colours to run, bleed and blend randomly. Alternatively prepare several different-coloured washes and apply them freely to the dry paper, again working from the top downwards and allowing them to bleed and blend at will.

This first application, sometimes called a 'base wash', normally consists largely of warm tints of pure colours upon which cooler, stronger and sometimes more neutral colours may be superimposed later. This is because warm, pale colours can easily be modified by superimposing blues, blue-violets and greens.

While such a base wash is still wet, colour can be lifted off by dabbing with tissue, pressing on a piece of blotting paper, or simply rolling a dry brush across the surface. If the wash is too wet, the colour will run back into the lifted area, so allow a few seconds' drying time. In my example here I used blotting paper, folding it and pressing it down firmly several times on its folded edge into the wet paint so as to achieve a linear effect.

Wet paint can also be lifted off with a sponge. Staining pigments are, as you might imagine, more resistant to lifting.

To lift colour from a dry wash, I use an acrylic brush dipped in clean water. It is important to remove the loosened paint immediately by pressing firmly with kitchen paper in order to control the shape and extent of the lift.

Backruns

When laying a wash, backruns may be caused by first loading the brush lightly and then reloading more heavily. This uneven distribution of water on the paper pushes pigment ahead of it, which eventually dries as a dark edge. Such accidents can be exploited to create random fringed areas.

Water or colour dropped into an almost dry wash will create small backruns (see also splattering above and page 87).

▲ **SALT**
Coarse and fine salt was sprinkled onto wet paint, left to dry, then brushed off.

▶ MASKING

Compare the hard-edged patterns created with masking fluid with those of the wax-resist method.

▶ WAX RESIST

A white wax candle or wax crayon produces a grainy effect. The wax cannot be removed completely later on, although a warm iron over blotting paper will lift some.

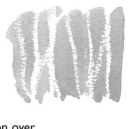

◀ INDENTATIONS

A door key or similar metal or plastic object can be used to create indentations in the paper.

To avoid unwanted backruns apply washes working steadily from the top downwards, loading and reloading the brush as evenly as possible.

Salt

This can be scattered onto areas of wet paint and left to dry in order to create areas of irregular texture.

Splattering

Paint can be splattered onto damp or dry paper. Practise controlling where the splatter lands; when working on damp paper, you also need to consider how much it will soften and bleed. Use an old toothbrush or bristle paintbrush, dipping it into a strong mix of colour and running a ruler or your finger across to create the splatter effect. It can be helpful to mask off areas which you do not wish to splatter by covering them with cartridge or kitchen paper.

Masking and wax resist

Masking fluid can be applied with a pen, a brush or a matchstick, or splattered onto the dry paper using a toothbrush as shown above. You can apply it to white paper, or to any area that has been previously painted and allowed to dry. When the masking fluid has dried, apply your washes or paint splatter. Be sure that these are completely dry before rubbing with your thumb to remove the masking fluid – but do not be tempted to hasten the drying with a hairdryer, as the heat process appears to 'weld' the masking fluid to the paper.

A wax candle can be used to similar effect in the 'wax-resist' technique. Applied to white, or to dry, previously painted paper, the candle grease resists subsequent washes of colour. It may be helpful to delineate with some pencil drawing the area to be masked or given resist.

Textured kitchen paper and plastic packaging

Pressed onto wet areas, these will leave a textured imprint which will vary in strength depending on the degree of pressure used.

Imprint

Firm pressure on the back of a knife blade or similar tool will make an indentation on watercolour paper. When a wash is taken across such an imprint the colour will settle into the indentation creating a dark line.

Clingfilm

Crumpled or stretched into creases, clingfilm can be pressed onto wet paint and left to dry *in situ*. Note that if it is removed too soon, the paint simply runs back into the textures created.

▲ TEXTURED KITCHEN PAPER

Here the paper was crumpled before being pressed onto the wet paint.

▼ CLINGFILM

Crumpled clingfilm, pressed into wet paint and left to dry, produces a range of interesting patterns.

Project:

Using special effects

Use some of the techniques shown on the previous pages to copy either of the paintings on this and the facing page.

Both began with a multicoloured base wash. This is done by wetting the paper all over with a large mop brush, and then touching in different colours and allowing them to run together randomly. Alternatively, mix up two or three different washes and apply them, working from the top down and letting them bleed and blend at will.

For *The Garden Gate* the base wash consisted of warm colours. When dry, the paper was re-wetted and a second wet-in-wet layer applied. The gate and other areas of definition were achieved by superimposing colours wet-on-dry, and often working negatively. Salt created the foreground texture. Can you identify any other experimental techniques?

The base wash for *Moorland Farm* (opposite) was ultramarine and burnt sienna. The shape of the building was lifted out of this wet wash using blotting paper. Some salt was scattered on the foreground and then crumpled clingfilm was quickly pressed on and left in place to dry. A few small touches of black were added for definition.

◀ THE GARDEN GATE

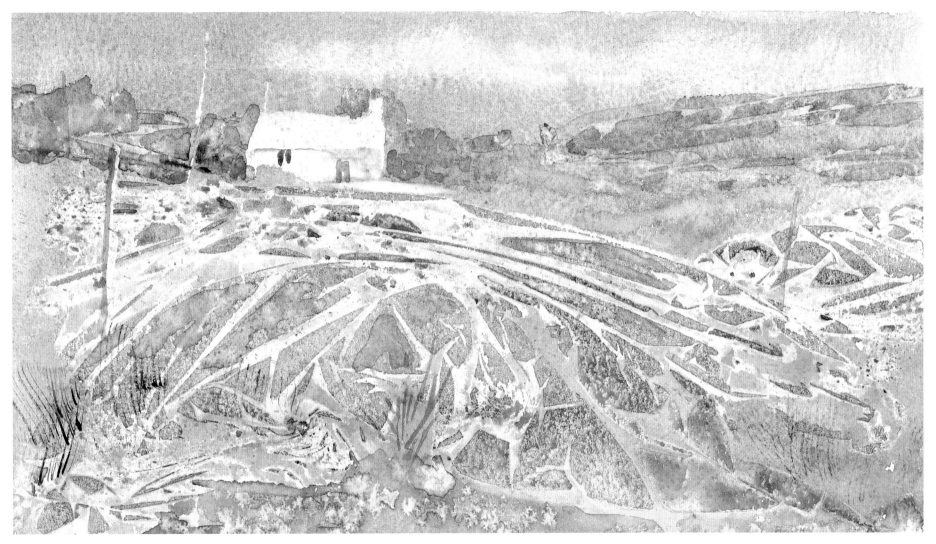

▲ MOORLAND FARM

Exercise:

Abstract beginnings using the imagination

Copying is all very well as a way of learning new techniques, but never forget that techniques are merely the tools of creativity. How can you carry delight in paint for its own sake into your own work?

In classes I have found the easiest way to begin is to create some really beautiful, non-figurative abstracts in paint and then to develop them through imagination. In truth, it is quite difficult to create an image-free abstract, as you may have discovered when working on the exercises on page 65. Try as you might, images seem to appear unbidden – finding faces in clouds or pictures in the fire seems to be a natural compulsion. In class, someone dubbed one of my paper collages, 'Boat entering harbour', and although the resemblance was unintentional, once it had been suggested I could see it for myself (see *Rectilinear Shapes* on page 64).

▲ STEP 1
Start with a few miniatures. Apply paint as for the projects on pages 88–9, in pale, multicoloured washes, or by wetting the whole paper and touching in stronger colour. Spray, splatter or feed extra colour into wet areas for random effects and texture, and work without any preconception. Create several such abstracts, using tints rather than strong mixes and keeping similar tones.

▲ STEP 2
Spread your abstracts on the floor and walk around each in turn, seeking any hint or suggestion of reality from every angle. Add a few light pencil marks to indicate a possible interpretation.

▲ STEP 3
Now ask yourself what is the least that could be done to that suggested image to enable others to see it, too. This might involve lifting out a more specific shape, or superimposing brushmarks or additional washes, working both negatively and positively. Develop the tones gradually and stop frequently so that you do not overwork. Perhaps refer to the painting on page 47 to remind yourself how nebulous an image can be.

Project:

Developing images from abstract beginnings

This project exploits our natural tendency to see images in abstract colours and shapes. However, repeating the exercise opposite on a larger scale in order to produce a finished work is likely to be more difficult than might be supposed. Most people's only experience of painting consists of observing reality and transcribing their observations onto paper. Teachers reinforce this approach with constant exhortations to ever more careful observation. Since this project stands that whole concept on its head, it would be wise to read again the aims of this lesson on page 84 before following the three step sequence opposite to complete this project, working no smaller than 38 x 28cm (15 x 11in). It might also be helpful to imagine you are illustrating a book of fairy tales.

▶ **DREAM LANDSCAPE**
I first laid a pale multi-coloured base wash. Viewed from a distance this suggested an image of Niagra Falls, which I enhanced by lifting and superimposing brushmarks in vertical and horizontal bands.

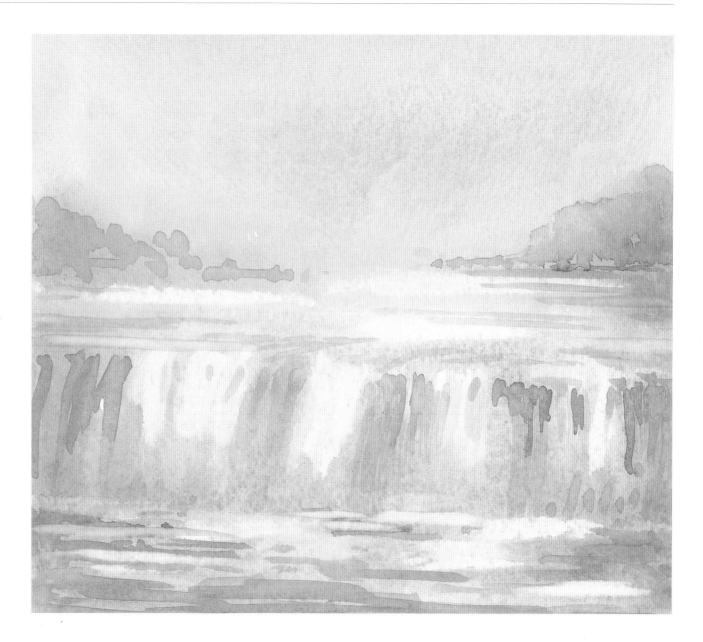

Abstract beginnings with a preconceived outcome

It is easy enough to make beautiful paint our top priority when there is no image to worry about, and it is not too difficult when the image is not preconceived but encouraged to emerge, little by little, from the imagination. As soon as we return to knowing what we intend to make a picture of, however, all our old working habits and concern for realism return. How are we to hold on to the idea of beautiful paint as a high priority when a specific and recognizable image is our intention from the start?

In the final lesson I suggest that making studies *in situ* but doing the actual painting in the studio offers one solution, by releasing us from a slavish adherence to exact representation. Here, however, I would like to pursue the notion of an abstract beginning.

Suppose when you apply the first multicoloured wash you use colours appropriate to the landscape where you are sitting, then your 'abstract' would relate to reality. Using the wet-in-wet technique, you could feed, drop or splatter colours into the foreground areas indicating the textures of things closest to you. There would be no hard-edged shapes, and yet it would be possible to recognize instantly which way up the

work was intended to be. This approach would, I think, offer an escape from former ways of working, while at the same time be more than capable of leading to an acceptable representation of the subject.

▲ The base wash is indicative of the chosen image, but was laid before adding the line drawing.

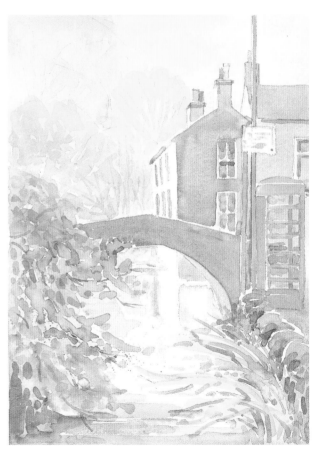

▲ THE OLD TELEPHONE BOX
The image was finished by working both wet-in-wet and wet-on-dry.

◄ BASE WASH FOR LAKE SCENE

Indicate the water line before laying the base wash so that the tree colours and shapes can be mirrored below.

▼ BASE WASH FOR LANDSCAPE

The bands of colour already aim to suggest landscape and distance. Try to develop the image with a minimum of superimposing and/ or lifting.

Tips

- It is best to start with warm colour and pale washes.
- If you intend to lift off paint, then use non-staining colours.
- If your chosen image contains reflections in water, mark the waterline and be sure to repeat the colours above the line in reverse order below the line.

Project:

Producing a preconceived image from an abstract beginning

Working *in situ*, make the usual preparatory studies (see pages 70–1). Apply the paint as described above *before* doing any drawing on the watercolour paper. This should save you from any temptation to colour in outline shapes. The only exception I would make here are any shapes you wish to preserve as white paper, either by masking them with fluid, or by painting around them.

When the base wash is completely dry, draw the outline shapes as dictated by your compositional study, regardless of whether the colours already laid down are in the correct positions or not. This migration of colours into neighbouring areas will contribute to a free and impressionistic interpretation. If there are any areas where you feel it imperative to regain white or almost-white paper, use the normal lifting techniques of damping and dabbing off.

Build up the image as you did in the previous project, stopping at frequent intervals to check that you are not overworking unnecessarily.

Abstract beginnings developed with other media

Although I set out in this lesson to celebrate the beauty of watercolour paint, as so often happens one thing has led to another. Now I want to suggest introducing other media in order to give added definition to abstract or semi-abstract images. This will have the added bonus of tempting you into more experimentation which is a constant theme of this book, and the specific subject of our final two lessons. Experimentation, as I mentioned at the very start, is the one sure route to painting progress and an essential element in the development of your innate creativity.

Some abstract beginnings are more easily developed with line than with paint. Many watercolourists make an initial pencil drawing which they consider an essential element of the finished work, but there is nothing to prevent us from working the other way round, i.e. adding pencil line to colour washes. For the lightest marks use an HB pencil, for a darker, stronger line use 2B. Softer pencils such as 4B or 6B will probably be too dominant unless the washes are also fairly dark. The trick is to do as little as possible so that the delicious abstract quality is not lost. Another alternative is

▲ ADDING PAINTED LINES
This rose head combines the soft effect of working on wet paper with a crisp paint line, applied with a fine brush when the paper had dried completely.

to draw into the washes with a fine brush, as in the painting of the rose on this page. This could be done with the appropriate colour, or black.

Project:

Adding definition to an abstract or semi-abstract beginning

Complete one of your abstract beginnings using pen, or pencil or a fine brush. You might like to look ahead to Section Three where there are projects using line and wash and a combination of coloured pencils with watercolour, which develop the use of line further.

◀ ADDING PEN LINES

Knowing that I wanted to produce a painting of irises on an abstract ground, I first laid a base wash and allowed it to dry completely. I then superimposed a second layer of wet-in-wet paint on the background working negatively around the flower heads. When that too had dried, I added definition with a limited amount of ink line, using a fine water-soluble pen. Touches with a damp brush softened the line here and there.

SECTION THREE

The first section of this book was concerned with helping you to achieve an accurate and convincing representation of the world about you. Acknowledging that the painting surface is actually flat yet in accordance with the conventions of Western art, the lessons concentrated on teaching you to mix the colours you see, to draw objects in correct proportion and relationship to one another, and to give them the illusion of solidity and of occupying three-dimensional space.

In the second section the emphasis shifted to aesthetics. The projects there were designed to help you create interesting compositions, to encourage you to take liberties with reality for the sake of a pleasing outcome, and to exploit the beauty of both colour and the paint medium itself. Throughout I hoped to encourage you to use your own intuition, resorting only to theories and formulae for a better understanding and on those occasions when intuition fails.

◀ LEAF SHADOWS AND REFLECTIONS

Finding a personal vision

The way forward

It may be that you have already been drawn into trying things completely new to you. In this final section I hope to encourage you on to even greater experimentation because I am convinced that therein lies the secret of continuing progress for artists.

In Lesson Nine, experimentation centres around the search for new subjects. Somewhere among them I hope you will find real inspiration, ideas or themes which speak specifically to you. In the final lesson I hope to encourage you to try different ways of working, even different media, for the sake of releasing your creative talent, ensuring continuing progress and developing your personal vision.

Most of us are resistant to change, perhaps because of a fear of failure or because we have only limited time to paint, yet over and over again I have observed that if students *can* be persuaded to try something new, progress follows almost inevitably. To put it conversely, if we always work in the same old ways we should not be surprised by the same old results. New subjects and new approaches teach new things and keep us constantly moving forward.

There are, however, some limitations to what can be learnt in the watercolour medium alone. Let me explain. However excellent the tutor, it has to be admitted that in the end the student learns most through experience. The experience of putting something onto paper, deciding if it works, keeping it or changing it if need be, and continuing in this way until a satisfactory conclusion is reached, is the means by which the painter learns. I call this process PACK: P for paint; A for assess; and C and K for change or keep. Through this process, the painter learns to make fewer mistakes as well as how to correct them, and above all, comes to know what 'works' and what does not. In short, PACK not only increases technical skill but also continuously sharpens aesthetic judgement, until little by little the 'amateur' becomes 'professional'.

The limitations of watercolour

Unfortunately this way of learning is not open to watercolourists because watercolour allows only limited correction. At best what the student can hope to learn from every failure is what not to do next time. It is notable that watercolour painting does not figure largely in art colleges, and this limitation is, I believe, the reason.

My conviction is that those who take up another medium, one that permits of the PACK process, make more rapid progress than those who do not. I do not suggest that you abandon watercolour altogether, only that you add a second string to your bow. It is for this reason that the final projects are in pastels and acrylics.

A change of subject

Have you heard the theory that what you have not seen as a two-dimensional image you cannot draw or paint? I think there is some truth in it.

Our world is full of images, not only in galleries and in our homes, but also in newspapers, magazines and books, to say nothing of the moving images on film and television. Artists take inspiration from such two-dimensional images just as much as from the three-dimensional world, and indeed from their own inner thoughts and feelings. I believe that the painted images you see and the ones that are stored in the memory serve not only to inspire us with subjects to try, but also make it easier for us to transcribe reality into paint.

Influences and inspiration

Not surprisingly watercolour images are the most helpful in this respect to watercolourists, while the oil painters find these the least helpful. We want to know how things might look in our chosen medium, and it would be even more helpful to see the original paintings for much is lost when large paintings are reduced to postcard size.

Some people feel that looking at how others have painted is somehow cheating whereas I think that to ignore the work of others is equivalent to attempting to reinvent the wheel! I do agree however that to model oneself on a single artist is a sad waste of individuality which in the end will stifle your own personal vision. Be sure therefore to take an eclectic view, and welcome influence from many different directions. Through this and through a willingness to try different subjects and approaches, and of course with practical painting

experience, comes your own vision and interpretation. Style in short is not something acquired, it simply develops in much the same way that handwriting does. We can make a start on all this today by creating a resource file.

▼ REFERENCE AND INSPIRATION
Here are some samples of images and studies from my own resource collection.

Exercise:

Building up a visual resource collection

Collect all sorts of images – anything which appeals to you. Never leave an art gallery without buying a few postcards, cut out pictures from magazines, save your birthday cards. Dare I suggest that you also vandalize your art magazines before you dispose of them?

Much of my own resource file is mounted on the pinboard in my studio,

and I think of these as ideas waiting in the wings. The majority are filed in a loose-leaf photo album under subject headings: Flowers, Landscape, etc. I make a point of displaying photos of a subject alongside various interpretations of the same subject in oils, watercolour, pastels and so on. In style they range from abstract to extreme realism and everything in between.

Saving your own sketches

Your own sketches, drawings and notes are also an indispensible part of a resource file – I keep them in separate workbooks. These contain my own drawings, sketches, colour notes, and tonal studies. I might refer to them if, for example, I need a few sheep for a landscape, or a boat for a seascape.

Since anything that interests or inspires me is grist to the mill, these A4 ring-bound pads of cartridge sometimes include snatches of prose

Aims

- To encourage an open-minded attitude to subject matter
- To offer a thematic approach to subject matter
- To encourage and enable creativity and the development of a personal vision

or poetry and occasional musical references. In these workbooks it is impossible to maintain anything resembling a filing system, and they do become rather messy as I tear out pages to pin up while I work. That doesn't matter. They are a source of both ideas for paintings and of reference material. START YOUR OWN RESOURCE FILE TODAY!

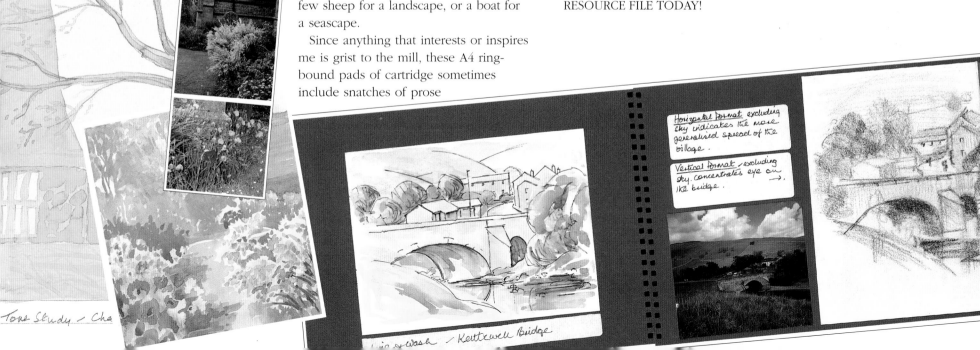

Tone Study - Cha

Pen & wash - Kettewell Bridge

Horizontal format excluding sky indicates the more generalised spread of the village.

Vertical format, excluding sky concentrates eye on the bridge. →

Finding an interest, following a theme

One thing your newly formed resource file should uncover is any thread or theme running through the collected pictures. Perhaps no such interest has yet emerged, but in time I am sure it will. Meanwhile over the next few pages I want to offer some possibilities for you to explore.

Some painters have had a passion for a particular place: one remembers Stanley Spencer and Cookham, or Cézanne and Mont St Victoire. Others have found a lifetime's work within the confines of their own home and garden, like Bonnard. Monet actually designed his own garden in order to paint it.

Visit any amateur exhibition and you will see that many learner painters have become entrenched in the romantic landscape tradition. There is nothing wrong with that, except that it has been done so thoroughly and so well by so many that it is hard to see it with fresh eyes. Perhaps more to the point for learner painters, long-distance views and wide-open spaces are very difficult to paint. A more limited viewpoint is much easier to cope with.

Open your eyes to potential subjects within a short distance from where you stand – flowers or grasses in close-up, for example, a rock pool on the beach rather than a seascape, some corner of an old boatyard, or a few shells or pebbles or other small objects.

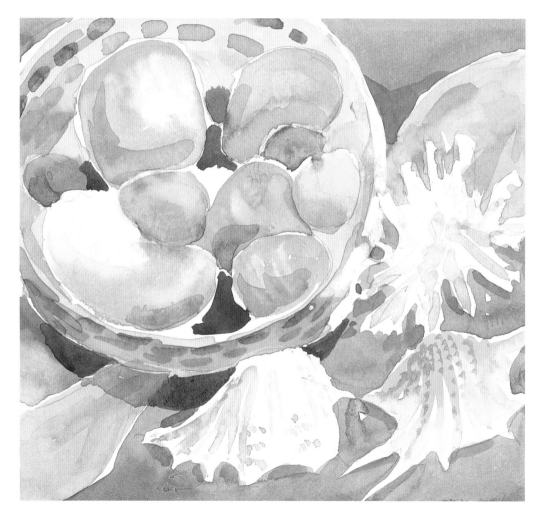

▶ PEBBLES AND SHELLS
This commonplace subject viewed in close-up and from above provides the opportunity to combine simple shapes and forms with subtle tints of colour.

Project:
Painting a close-up view

I discovered this subject by accident when I started to keep small shells in a fisherman's fly box. I became fascinated by the negative shapes trapped between the curved natural forms of the shells and the straight lines of the box. Later I tried seed heads and tiny garden bulbs, and soon found the subject lent itself to different colour combinations. In the pages which follow, I am sure you will see how this interest in straight lines and curved shapes developed and how it continues to engage my interest.

Try some close-up subjects for yourself.

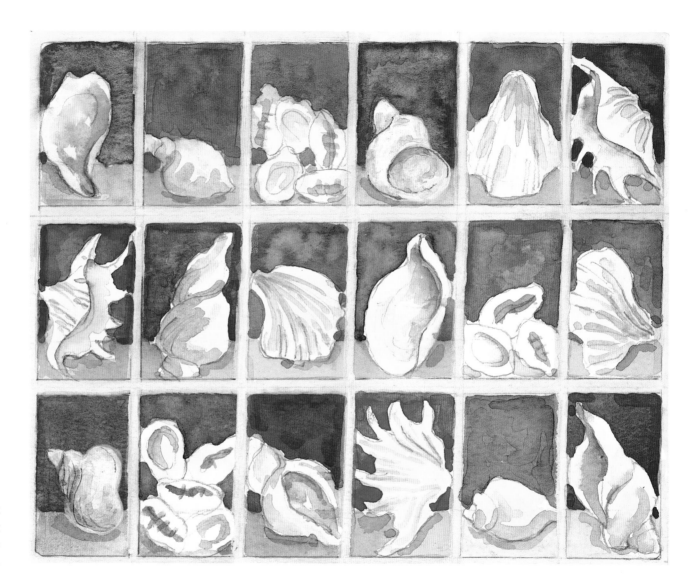

▶ BEACH BOX BLUE
The different types of shells in each segment of the display box exploits the contrast between the curvilinear shapes of the shells and the rectilinear divisions of the box.

Views through windows and doors

One way to limit your view is to make use of windows and doors. Start by going around your home looking at the views you can see through your doorways and window frames. Even slight shifts of your position relative to the frames will make a big difference to what is seen through them. Views onto other houses, or perhaps a yard and some sheds, can be just as exciting as those affording a more picturesque image of a garden.

Alternatively, you can look in from the outside, rather than out from the inside. For either approach some licence is possible – perhaps a climbing shrub or a dozing cat introduced on the outside, a figure or vase of flowers glimpsed through the glass on the inside.

For one painting, I used two window panes to combine a view seen from a cottage window with one of the cottage itself. On another occasion I painted the view from a 16-pane Georgian window: by painting one pane at a time and slightly shifting my position for each one, the 16 mini-views appeared oddly disjointed, which gave the effect of walking past a window rather than standing still and gazing out of it. Similar liberties could be taken with four window panes by depicting the same

view four times in four different seasons.

Then there is the opportunity to combine looking in or looking out with reflections on the window pane itself. Some modern city buildings have highly reflective surfaces and windows which mirror neighbouring buildings and the sky to dramatic effect.

Frames and patterns

Windows, doorways, arches and so on can both frame a view as well as being an integral part of the composition. Gardeners will be familiar with the framing potential of hedging and topiary, pagodas, and weathered stone or brick archways. Walking in the countryside many years ago I came upon a derelict barn which perfectly framed the distant landscape beyond. One artist of my acquaintance painted a most beautiful series of landscapes seen through the rounded arches beneath a disused railway line. Seeking such subjects is not the same as using a viewfinder to select a part of the landscape. It is important to appreciate that whatever frames the view is an essential element of the composition.

The rectangular shapes of buildings, and the way they align or mesh in with the lines and edges of the window frame, can be exploited to create the sort of interesting patterns we tried out in our

▲ ▶ FRAMED VIEWS
Here are three views of the same scene. In the first, I ignored the framing offered by the veranda and open doors. In the second, I incorporated both the framing and the reflections in the glass. In the third view, painted closer to the subject and from a slightly different angle, the natural framing of flowers and foliage become, in effect, the most significant element of the work.

geometric paper collages (see page 65). Compare the painting of the patio door here with that of the display box on page 101. Do you see how the straight lines of the patio door and the table are an essential component of the composition, just as the box has equal importance with the shells?

Project
Painting a view through a window

Try a few small sketches to help you make your choice of window and viewpoint. You may wish to include some part of the room too, as I have done. Patio doors, half or fully open, or windows made up of many small panes, offer all sorts of possibilities. Whether this turns out to be one project, or a lifetime of projects, the important thing is to keep your eyes and your mind open to all the potential subject matter around you.

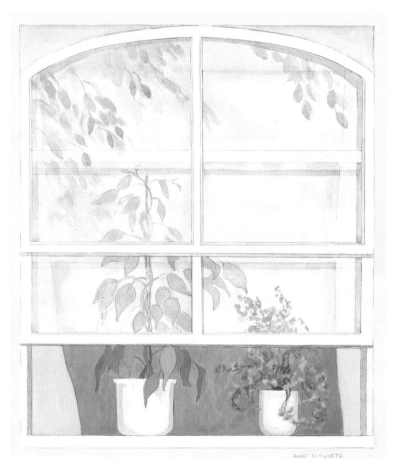

▲ LEAF SHADOWS AND REFLECTIONS

◄ THE PATIO DOOR
Here the glass door not only frames the view outside but also forms an important part of the whole composition.

Taking inspiration from a special place

Some artists are remembered as having been inspired by a particular place. Cézanne and Monet have already been mentioned, but there are many more, among them Constable and his beloved Dedham valley in Suffolk, Gauguin and Tahiti, Andrew Wyeth and Maine, USA.

It would be a mistake to imagine that these artists were all motivated in the same way. Constable, for example, painted the area where he was born for most of his life. He had a deep love of the countryside, yet aimed to portray what he saw with simple honesty rather than overlaid with intense emotion. Stanley Spencer, on the other hand, invested his beloved Cookham with a highly personal religious view. Gauguin also had a strong inner vision which charges his flat decorative shapes and use of colour with expression and meaning, while Cézanne's devotion to Mont St. Victoire was not so much an emotional or spiritual one as an obsession with structure, form and space. In contrast, Andrew Wyeth's images convey, through their austere simplicity, a somewhat strange and mysterious spirit of place.

If you find that your interest is excited by a patchwork of fields, it may well be because you already have a predisposition towards patterns of colour and shape – but equally it could be that you see its potential for expressing your feelings or inner vision.

Preparatory studies

Sometimes one returns to a certain spot only to be disappointed and puzzled as to what had seemed so attractive a few days earlier. Perhaps you had not realized how important light effects are to you, so that without sunshine and cloud shadows the view has lost all its charm. This is where making preparatory studies can be useful: they can help you identify the attraction of a particular place, and thus enable you to focus on that aspect of it.

▲ PASSING THE PARK
This coloured pencil study was made during my 'parks and gardens' period. As in the previous projects which were framed by windows and doorways, I chose to view this scene between two railings.

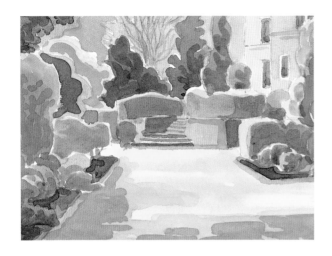
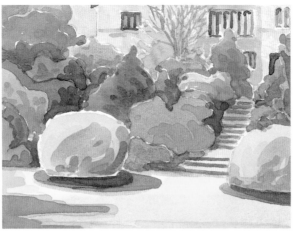

Project:

Working in parks, gardens and other special places

Too often we set off to look for a new and different location, and indeed waste much time in the search. The aim of this project is to encourage you to find all you need for many paintings within one small area.

If you already have a special place, somewhere that repeatedly draws you back, you will need no further encouragement from me. If not, take as your theme any public park or garden, and make a series of studies. Many

stately homes with gardens and parkland are open to the public (see, for example, *Castle Gardens* on page 71). Most towns and cities have parks or more formal gardens, some with the added interest of bandstand, bowling green, walled flower garden, topiary, fountain or statue. Your studies may lead to more than one painting, whether worked *in situ* or back in the studio. Should you become a little obsessed with the place, so much the better!

▲ MORTON CLOSE
One summer I spent many hours in the garden of a friend's house. There was a quality of stillness and quiet which I tried to capture with a stylized treatment. I made many drawings and colour studies, and eventually mounted these three separate views together. The way that they appear to be adjoining and are yet not quite right is intended to convey the dreamlike atmosphere I felt there.

Non-visual inspiration

So far in this book almost every project has had as its starting point things seen – the real world. The sole exception was the project in Lesson Eight where we interpreted an abstract beginning with the aid of imagination. It is true that sometimes we have combined two or more images into one, or used artistic licence for the sake of improved composition or dramatic effect, but the work has always been based on external reality. Even those painters already mentioned who used landscape as a vehicle for expression of feeling, or who interpreted a scene according to their own personal vision, took as their starting points real places, people or objects – the visible world.

There is another world, however: an internal one. Dreams, memories, stories and imagination can also be starting points for paintings. For example, look at the work of visionary painters, especially William Blake. Often combining etching with watercolour, he created images that can only be understood in terms of dreams and visions. If you do not know his work the titles alone are indicative – *The Ancient of Days; Jacob's Ladder; Wise and Foolish Virgins* (see my small copy).

The work of Henri Rousseau also comes to mind. Although experts are divided as to whether or not his work can be categorized as naïve, he was certainly what we now call a 'leisure painter'. His work appears to be a blend of memory, dream and imagination.

Other examples include the Pre-Raphaelite paintings of the nineteenth century, which combined painstaking attention to detail with themes of medieval chivalry, storytelling and biblical scenes, and had titles such as *The Death of Orphelia* (John Everett Millais), and *The Girlhood of the Virgin Mary* (Dante Gabriel Rossetti).

Finding a theme

A few years ago I was asked to spend a few days as artist in residence at a local school and wanted to find a subject that would fire the children's imaginations. In the headmaster's log of a hundred years earlier, I found a reference to a boiler explosion in a building nearby which had killed some children in the school yard. His entry for that day began with the matter-of-fact words, 'I had to send the children home today…' which I found poignant and haunting. The school building externally was just the same as it had been then. Using on-the-spot drawings, we made it the setting for this tragic story, adding some ghost-like figures of children in Victorian dress, drawn from imagination.

▲ WISE AND FOOLISH VIRGINS
This is my copy of Blake's painting of the parable in St Matthew's gospel to which, of course, the title gives the clue. Both the content and title tantalize the imagination.

I had to send the children home

today...

◄ SEND THE CHILDREN HOME Actual events can be the inspiration for a painting, as in this work that is based on a tragedy at a local school.

Project:

Working from your imagination

This is likely to be such a change from your normal way of working that it will be hard to know how to begin. Is there some incident from your childhood which is still strong in the memory? Have you had a dream recently that refuses to go away? Perhaps you could imagine yourself illustrating a gospel story or a fairy tale, or a piece of family history.

I can offer two different approaches to this project, although I think both require some sort of compositional planning.

One method would be to paint from the heart and the imagination without any reference material other than a tonal study. Distort the figures or any other part of the image as much as you wish, use colour expressively rather than realistically as Blake did, and do not concern yourself with careful drawing.

In contrast to this approach, you could follow the Pre-Raphaelites and work from suitably dressed and carefully posed models, and with great attention to detail, realistic drawing and colour. Sketches and photographs would provide similar reference material.

Taking inspiration from a special event

Have you heard the advice to 'wait until the hairs on your neck stand up before starting to paint'? In my case that would have involved long periods of waiting and not very much painting! Just occasionally, however, I have been swept off my feet by a combination of something extremely beautiful and highly emotional. The wedding paintings on these two pages were inspired by just such occasions.

All weddings have an element of drama. Animated groups of people in beautiful clothes, the stage-like settings of church and reception, the posing for photographs, and all the symbolism of beginning a new life together. The baptism of a new baby, a golden wedding celebration or some great national event might be equally inspiring to others.

Working methods

My two paintings here were studio projects which involved bringing together a variety of source material, and gave me the opportunity to include some personal or universally understood symbols.

In *Summer Wedding*, the setting is a restaurant opening onto a garden. The similarity between the windows and church windows was striking, and so I enhanced the effect by adding tints of

colour to the upper panes. I feel their shapes are also reminiscent of a proscenium arch, adding a certain theatricality. The setting was drawn *in situ,* but on the following day.

The figures were then added from photographic reference after I had made several compositional studies. The

positioning of these figures is, in some cases, symbolic of the individuals and their relationships, but this is personal symbolism – it can only be appreciated by the people concerned. Such symbolism is in contrast to the more universally understood symbols of church windows or proscenium arch.

▲ SUMMER WEDDING

◄ AUTUMN
WEDDING

Project:
Painting a special occasion

Colour was used largely expressively, to create a sense of drama and to evoke the mood of the scene.

For *Autumn Wedding* I chose a triptych format. Only the centre panel was drawn on the spot; the two outer panels were based entirely on photographs. In this case, the compositional studies helped me to relate the three panels to one another, aided, I hope, by the limited colour scheme.

These watercolour studies might be considered works in their own right, although eventually I used them to create an acrylic painting, because acrylics enable more minor changes to be made (see the acrylic projects in Lesson Ten).

Working from memory, sketches and photographs create a painting of a special occasion. Invest it with drama through the use of colour and tone, and incorporate any personal or universal symbolism which seems relevant.

A change of approach

In the last lesson I referred to the 'romantic landscape tradition', by which I meant a way of painting picturesque views in a style reminiscent of the eighteenth or nineteenth century, and in a standard oblong or 'landscape' format. I repeat that there is nothing wrong with wanting to paint in this way, but it is a very limited approach to painting. I have been trying to encourage a more open-minded attitude to some of the alternatives and, if possible, to help you discover some theme which you could explore at greater depth, rather than engaging in a constant search for yet another picturesque view. I am conscious

◀ KILNSEY CRAG

This view – which is also known as 'Turner's View' because the artist sketched it in 1816 – demands a wide landscape format.

Aims

- To enable continuing progress via open-minded attitudes to formats, methods, processes and media
- To encourage experimentation as the means to greater enjoyment and achievement
- To explain how the PACK approach (Paint, Assess, Change or Keep) enables continuing progress and development, and to encourage its use

that I have barely scraped the surface of the myriad possibilities, but hope that you will continue to feed your mind by going to see exhibitions and by looking at illustrated books. Meanwhile we must move on to other ways of making progress, developing your creativity and discovering a personal vision.

In this lesson I want to utilize the fact that a change – virtually any change – in the way in which you work will almost inevitably lead to painting progress. The changes we shall consider are those of

the formats, the scale and the speed at which you work, and the methods and even the media you employ.

Choice of format

'Landscape format' is how we describe a horizontal oblong, while for equally obvious reasons a vertical oblong is generally referred to as a 'portrait' format. Sometimes there is fair justification for reversing this choice of format – for example, a portrait may feature a reclining figure, or a landscape a tall building –

but aside from these special cases we are content, on the whole, to accept the status quo. Indeed we are positively encouraged to do so, not least by the 'ideal' proportions of the Golden Section and the standard shapes of canvases and pads of paper. Nevertheless we need to be alert to the needs of the subject, while at the same time being willing to break free once in a while.

Project:

Trying an elongated format

Some subjects demand a change. A feature of the Yorkshire Dales landscape so familiar to me is a wide flat valley with fells rising steeply but not necessarily to great height on either side. When the subject is forced into a typical quarter imperial format – 38 x 28cm (15 x 11in) or roughly A3-size – the valley bottom has to be reduced and the whole character of the view is lost. The solution, of course, is to use an elongated format. A seascape might offer similar potential. Try finding a subject which demands an unusually elongated format.

Project:

Trying a square format

Some painters have a predilection for a particular format. I suspect I have a preference for squares because they force me away from compositional clichés. Make a square viewfinder and use it on any still life or landscape composition. See where the image crops best, and look at the effect this format has on the composition.

Project:

Painting a vertical landscape

In the search for something a little different, I sometimes suggest that students try painting a landscape in a portrait format. In hill country especially, this 'vertical slice' format lends a new perspective to landscape. Try painting a vertical slice of an otherwise familiar landscape.

▶ **THE VILLAGE FROM FELLSIDE**
The unusual portrait format of this landscape presents us with a new and more focused view of the scene.

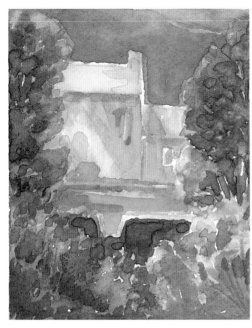

◄ MIDSUMMER
DAY IN THE
VILLAGE
The diminutive
scale landscape
(10 x 13cm/4 x 5in)
intensifies both
the impression
of the scene, and
also the colours.

A change of scale

Just as we tend to think of all landscapes
being created within a more or less
standard rectangle, so we can become
entrenched in working to a particular
scale. In so doing we are once again
losing opportunities to develop creativity,
make progress through experimentation
and develop a personal vision.

The manner in which you work can, in
fact, be revealing of personality.
Flamboyant or timid, careful or slapdash,
it is likely that there is a way of working
which is right for you, but it may be that
you have not yet discovered what it is.

Many of us continue to work in ways
we were taught years ago, and which we
have come to believe is the only way to
paint. These two projects aim to
encourage you to try extremes of scale.

Project:
Producing a small painting

I am not suggesting that you paint a
miniature (although you will find books on
the subject which might encourage you to try
this specialized art form), but I am asking
you to work smaller than A5, perhaps 10 x
13cm (4 x 5in). The effects of a landscape
reduced to this size could be intense and
jewel-like, especially if you are using pure
colours; with an impure colour scheme, it
might be sombre and mysterious.

There will be other choices to make,
too. Will you use normal-sized brushes
and thus be forced to create a simplified
impression, or choose smaller brushes
enabling a more detailed approach?
Such small works often look best in
disproportionately large mounts.

For the sake of comparison, you could
base this project on an earlier one much
reduced in scale, or else you could use
the same new image for both this
and the next project.

Project:
Producing a large painting

For this you could try any subject. A
large-scale landscape would enable you to
portray great sweeping spaces, while
flowers rendered larger than life can
change an otherwise commonplace image
into something quite extraordinary.

Again several different approaches are
possible. Working at a larger scale might
encourage a broad and gestural use of
large brushes as you stand at an easel,
and give you an experience of painting as
a vigorous and exciting physical activity.
Alternatively you could try building up
large washes layer on layer.

I suggest working on a full imperial
sheet (76 x 56cm/30 x 22in). Do
remember that the larger the paper and
the greater the amount of liquid used, the
more potential there is for the paper to
stretch and cockle, so either use a
638gsm (300lb) paper or stretch any
lighter-weight papers.

▲ POPPIES

◀ This small
section is to scale.

A change of speed

How long does it take to paint a watercolour? I might as well ask, 'How long is a piece of string?' One professional told me that if it took longer than two hours he would be guilty of overworking. Another thought that two weeks would be typical for one of her paintings. To what extent these timescales include choosing a view or arranging objects, making studies, and what I call 'thinking time' I cannot say.

It is likely that you already have your own 'normal' speed, but is it right for every painting, and has it become just an unthinking habit? Unthinking habits inhibit progress and stifle creativity, so once again I offer two projects designed to encourage experimentation.

Of course the size of a work, the intricacy of the subject, the techniques and processes used, and your intended outcome are all determining factors. In addition, when painting outdoors – especially in a changeable climate – one often feels one is working against the clock. Therefore in order to compare experiences of working at different speeds, let us at least establish a reasonably 'level playing field' by working in the studio and to the same scale, and basing our paintings on the same subject.

Project:
Painting at high speed

Do as much forward planning as you wish, but aim to go from blank paper to finished painting in half an hour. This will inevitably mean having to work in the direct method.

I have drawn and painted the subject in my two examples several times. This first, quickly executed one was painted in the studio in about half an hour as a demonstration. I don't normally agree to demonstrate for fear of giving the impression that 'this is how to paint', when of course there is no single way since we are all individuals and every painting is, and should be, a new challenge. In this instance, however, several students had asked how to overcome the problem of overworking, and others were asking how they could learn to simplify. I suggested a series of timed exercises starting with a one-hour painting, then three-quarters of an hour and so on. Not surprisingly the group threw down the gauntlet!

I worked from sketches and memory, used a limited palette, and drew the outline shapes with a No. 8 brush and a very pale wash of raw sienna which is quicker than using a pencil and can

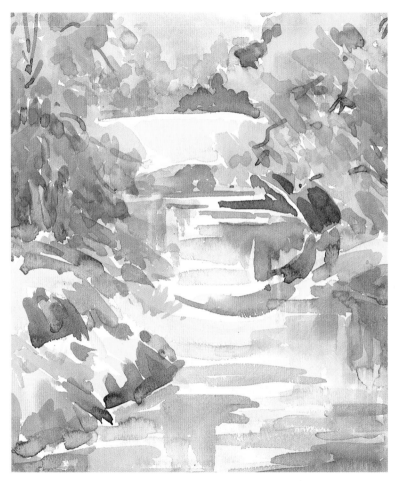

▲ STILL WATERS

easily be corrected by blotting off. The work measures 30 x 36cm (12 x 14in) and there was no 'thinking' time!

Project:
Painting slowly

For this there are more options regarding techniques and processes: the direct method using smaller brushes for greater detail and more careful delineation is only one way. You might prefer to try distilling the subject into simple shapes, tones and colours, rendered as a series of superimposed washes, in the manner of John Sell Cotman. Another possibility is to use a dry-brush method in which a small amount of dryish paint is brushed across the surface of the paper – an effective if somewhat labour-intensive way of building texture and tone.

I worked up this second version of my subject from sketches and a photograph and a compositional tone study. I used a *pointillist* technique – a series of small brushmarks with tiny gaps of white paper between, rather in the manner of the French painter Georges Seurat. This technique enables a gradual build-up of tones and a weaving together of colour. Rather than complete one area at a time, I tried to take one colour and use it wherever appropriate, much as an oil painter might do.

It was a most enjoyable experiment for me, and I look forward to trying other variations which occurred to me as I worked. For example, one could apply all the blue marks first to establish a tonal image before adding other colours, or perhaps eliminate the white gaps or vary the size of the brushmarks.

Allow yourself unlimited time for studies and for the work itself, accepting that you may need several sessions so that this project may occupy you for some weeks.

▲ STILL WATERS 2

▲ ON THE BEACH
This beach scene was completed in the studio. Note the reflections of the three figures in the water, which adds to the quality of translucence and light.

A change of method

Have you been led to believe that all landscape painting should be done on the spot, and that failure to do so is in some way second best or possibly even 'cheating'? Perhaps I gave you this impression myself, especially in the early lessons, by stressing the need for careful observation. On the other hand, later lessons have advised taking all sorts of liberties with reality for the sake of an aesthetically pleasing outcome. So it is

Some problems of working outdoors

When you work indoors you can, to a large extent, control your working conditions, and let's face it – working outdoors is inconvenient! Light and weather are not constant, the wind blows, midges bite, there may be curious onlookers, and then there are all those materials and pieces of equipment which you need to carry to your chosen location (see pages 8–11). Here are a few of the problems you should anticipate when painting outdoors, with a few tips for coping with them.

■ **Plan and pack ahead.** Dress appropriately with either sunhat or eye-shade, or plenty of warm layers and stout footwear. I usually add a camera and a thermos flask, and midge repellent in summer.
■ **Consider your working conditions.** I try to find some shade to work in to prevent paper dazzle. A stool, plastic tray or sheet on which to lay out equipment can save losing a brush in long grass. On windy days, I suspend a polythene bag weighted with a stone from my easel to lower the centre of gravity.
■ **Dealing with onlookers.** These can be a serious distraction. I like to have my back to a wall or bush to avoid people creeping up and startling me, and just hope that my look of fierce concentration is a deterrent. I am far too self-conscious to paint for spectators and sometimes have to resort to taking a coffee break or even walking off for a while.
■ **Expect the unexpected.** My view of a quiet corner of Haworth village, where the Brontë sisters were born, was once obliterated by the arrival of a Pickford's removal van, and my efforts in the countryside seem to act as a magnet to every sort of farming activity. In spite of all this, for me, working outdoors is still a stimulating and exciting experience.

small wonder if you feel confused!

In fact, most painters balance these two aspects of creating a work of art, and must find a way of doing so which is right for them. We take in information through our eyes and then select, simplify or elaborate, synthesize and translate into paint. For some, this does mean working *in situ* from start to finish, because any work done away from the subject seems to lack vitality and veracity. They feel working outdoors generates a spontaneity and enables them to capture an impression in a way that simply does not happen in the studio. Others, however, feel that working on the spot turns them into mere copyists of nature and drives them to a more detailed approach than they would wish. *They* might say that while nature is their source and inspiration it is, nonetheless, only the starting point.

The two projects here are designed to help you experience the pros and cons of the two approaches.

Project:

Painting a landscape *in situ*

Use a viewfinder to help you select the best viewpoint. Before you begin, make a few preliminary studies as described on pages 70–1 to help you explore the

possibilities. If rain comes, these studies could become the basis for the next project, a studio painting.

Project:

Painting a landscape in the studio

Collect and display as much reference material as possible, but remember that the main advantage of studio painting is freedom from slavishly copying the scene. Photographs are no substitute for the experience of making studies on the spot, and should be used as additional reference rather than as a prime source. Spend as long as you wish in planning and envisaging the outcome before you begin. Remind yourself that painting is the creation of new images from old.

▲ BEACH AND CLIFFS
This example of a landscape done *in situ* shows a sliver of beach glimpsed between the reddish cliffs of the Algarve in southern Portugal.

A change of medium

We cannot pretend to have explored the full potential of watercolour until we have tried using it in combination with other media. Pen and ink made a brief appearance on page 95 as a means of giving added definition to a flower painting, but this project starts out with the intention of combining watercolour washes with ink line.

Line and wash

In earlier times watercolour was used to enhance ink drawings with tints of colour, from which it developed as a medium in its own right. Today we often associate line and wash with illustration, especially of architectural subjects, but the method is equally suited to the delicacy of flowers and plants, and to figures and animals in action. Many, myself included, also find it a quick and effective way of making outdoor studies.

Traditionally the ink drawing is executed first and, when dry, enhanced with pale washes of colour. For this method be sure to use a pen loaded with waterproof ink (see the materials section on pages 8–11). In addition to ready-loaded pens, there are many different inks available for use with dip pens. Because they come with a wide range of nibs, dip pens enable a greater variety of lines and

◄ ALGARVE LANDSCAPE
Using line and wash is a quick and effective way of making outdoor studies.

marks; these can be varied further by applying different degrees of pressure.

There is a risk that laying the washes will become a colouring-in exercise. To avoid this, allow the wash to escape beyond the ink line, or develop both line and wash in turn.

Alternatively, start with a few pencil outlines, then lay washes of pale colour. When these are dry, work into them with the ink line.

Project:
Making a drawing first

To try out the new technique, you could make an ink drawing and, when dry, add monochrome tonal washes for areas of shadow, using a ready-made grey or a neutral mix of three primaries, or the drawing ink diluted with water.

Alternatively, use a pen loaded with water-soluble ink for the drawing, and blend hatched marks into tonal wash areas with a damp brush.

Project:
Experimenting with different surfaces

Using any subject, combine ink line with watercolour washes. This is a good time to experiment with papers of different surface texture. A smooth (hot-pressed) paper enables more flowing ink lines. Most botanical painters choose a smooth surface for greater detail and sharper definition. Washes behave differently, too, without the holding texture of NOT (cold-pressed) or rough papers.

▶ HIGHAM IN SPRING
This line-and-wash study was produced on hot-pressed paper. The smooth paper prevents the nib snagging as it is drawn across the surface.

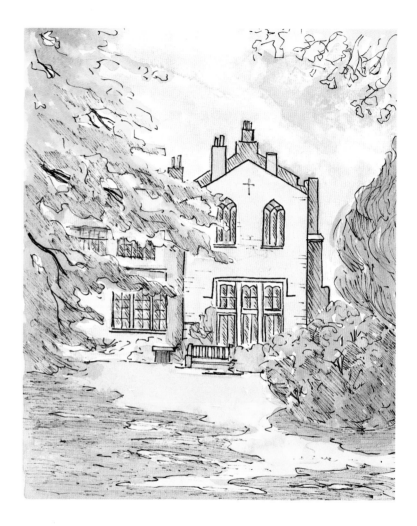

Coloured pencils

Coloured pencils are another useful addition to the watercolourist's repertoire. Many makes are available, and of these the softer ones are the most appropriate for use with watercolour. They are similar to pen and ink in that they enable a combination of flowing washes and graphic line and mark. Just as inks are available in water-soluble and non-soluble form, so are coloured pencils. Like their close cousins Neocolor crayons which are chunkier and therefore broader, coloured pencils are ideal for holiday sketches and studies. Small and light to pack, you need only add a block or pad of paper, a tiny bottle of water and a small brush.

Possible effects

If you wish to begin with lines and marks, you must be sure to use non-soluble pencils or the lines will dissolve as the washes are applied. I use mainly the soluble coloured pencils and work the other way round: that is, I start with a light, ordinary pencil or brush drawing to establish the main shapes, then apply the washes. When these are dry, I work into them with the pencils to add line, mark and texture.

When I am working with flowers, I sometimes do most of the work with the coloured pencils and then use a damp brush to blend the colours and marks together in some areas. However, I find that if I take this blending too far I end up thinking I might just as well have used watercolour paint alone, whereas my aim is to exploit the combined paint/draw possibilities to the full.

It is even possible to add a little speckled texture to damp wash by holding a soluble pencil above it and scraping the 'lead' with a sharp knife.

Project:
Combining watercolour with coloured pencils

Produce a work which combines watercolour with either coloured pencils or Neocolor crayons. Consider the paper you will use – rough, NOT (cold-pressed) and smooth papers each enable different effects.

▶ PELARGONIUMS
This study was produced entirely in water-soluble coloured pencil, softened in places with a damp brush.

▶ TULIPS
Watercolour was enhanced with coloured pencil for added definition in this study of tulips.

Rescuing a painting

Watercolour purists are offended at the idea of introducing other media. I am offended by failure and will use whatever is necessary to achieve a pleasing outcome. At the simplest level, this might involve pen and ink or coloured pencils for added definition, or perhaps a few touches of gouache (opaque watercolour) to recover a lost highlight on a vase.

Analysing the problem

Major disasters, however, demand more drastic measures. The first priority is to identify the problem. As a painting progresses, I frequently place it on the floor, position my L-shapes (see page 42) and move round to view it from every angle, because the more difficult it is to see what the image represents, the easier it is to spot any weakness in the composition. Sometimes I extend my arm and use my hand to cover up first one part of the work and then another. If the painting suddenly appears to improve I know I have found the troublespot.

Once the problem has been located, the next step is to decide what can be done about it. Often some minor change or addition will suffice, but for a serious problem, or for paint that has lost its freshness, there is nothing to lose by introducing some opaque medium.

Opaque media are those, like oil paint, which use white pigment to make colours paler; applied densely, they are able to obliterate whatever is underneath. In former times I would usually resort to gouache for rescue operations: the techniques were familiar to me from the poster paint we used at school, and whether in creamy consistency or milky washes, gouache combines well with transparent watercolour. These days I more often use acrylics in much the same way because, unlike gouache, acrylics permit virtually unlimited reworking. (If you are unable or unwilling to invest in acrylics, please read the notes on gouache in the panel on page 125.)

Before trying over-painting with opaque paint, however, you might like to see what can be achieved with pastels or something similar, used on their own or in combination with charcoal or ink. The ability to work in mixed media is an enormous creative freedom, enabling one to choose whatever will best serve your intention – and it's fun!

Project:

Rescue operation

Take any painting which you feel has failed, try to identify the problem, and allow plenty of time to decide what needs to be done before you begin. Use pastel or some other type of chunky crayon, putting plenty on to partially or completely cover the underlying watercolour.

When the watercolour paint in my example – a painting of wild flowers – had become somewhat tired and muddy, I used a mix of artist's pastels and water-soluble crayons to bring it to a more satisfactory conclusion. It is not the work I originally intended but anything is better than tearing up one's efforts.

▶ STANDING TALL

Acrylic paints

Acrylic paint is water-soluble, but once dry, has a permanent finish, i.e. it is no longer water-soluble. This means that the paint cannot be corrected by washing off; however, layers can be superimposed without any loosening of the under-layers.

The versatility of acrylic paint can cause confusion. In dilute washes and on watercolour paper, the effects are transparent and virtually indistinguishable from watercolour. When painted on canvas or canvas board, in much thicker consistency and using white pigment to make colours paler, acrylic paint can look much like opaque oil paint. In between these two extremes lies a more creamy consistency, rather like gouache, which is still dense and opaque.

Acrylic techniques

The acrylic projects in this book have been done on watercolour paper using the paint in this gouache-like form. If white is added to it to make the colours paler rather than diluting it with extra water, the creamy consistency can be maintained throughout for that opacity which enables unlimited repainting and correction. In addition, occasional transparent washes of colour superimposed on top of dry opaque paint allow minor adjustments of colour and tone without obliterating the underlying brushwork. It is also possible to combine transparent washes with areas of dense opaque paint in a single work.

The box below lists the equipment you will need for painting with acrylics. For further information and the many other ways to use acrylic paints, see *Acrylic Workbook* by Jenny Rodwell, also published by David & Charles.

Acrylics checklist

Colours
For the final projects in this book you will need the same or similar colours as those for watercolour, in tube form and with the addition of a large tube of white.

Brushes
Acrylic brushes are made from synthetic fibre designed to withstand long periods in water and vigorous cleaning since paint must not be allowed to harden on them. Available with long handles for those who like to stand at an easel as I do, or short handles for those who prefer to sit, I use two flats – one 1cm (½ inch) and 2.5cm (1 inch), and two rounds – a No. 10 and a No. 4. If you have bristle brushes of any shape or size, they will serve. I use my bristle oil brushes, especially for larger works, first giving them a good soapy wash to remove every trace of grease.

Keep the brushes you are using in a shallow tray of water so they lie flat rather than standing on their bristles in a jar of water, and wash them thoroughly after use. Although almost anything goes, brushes of natural hair may be a little too soft for the way we shall be using the paint.

Palettes
Since we are using the paint in a creamy consistency we need a flat white surface on which to mix it. You can buy a white plastic palette with a thumb hole or a tear-off paper palette, or use a couple of old dinner plates. Lay out your colours along one edge and keep the paint from drying out with an occasional spray of water. Use the rest of the surface to mix colours with your brushes or a mixing knife, cleaning it and replenishing paint as necessary. Alternatively buy a

'Staywet Palette'. These are designed to prevent paint from drying out too rapidly. They consist of a tray lined with blotting paper which is kept damp, and a 'membrane paper' (I use kitchen parchment) which is pressed down onto it, on which to lay out the pigments.

Gel retarder
Gel retarder is available in tubes. Mixing a little of it with every colour as you squeeze it out slows down the speed at which the paint dries on the picture surface, making it easier to blend colours together. Note that the more water you use, the less effective the retarder will be.

Other items
You will also need a jar for water, and a rag or kitchen roll for drying brushes after rinsing them.

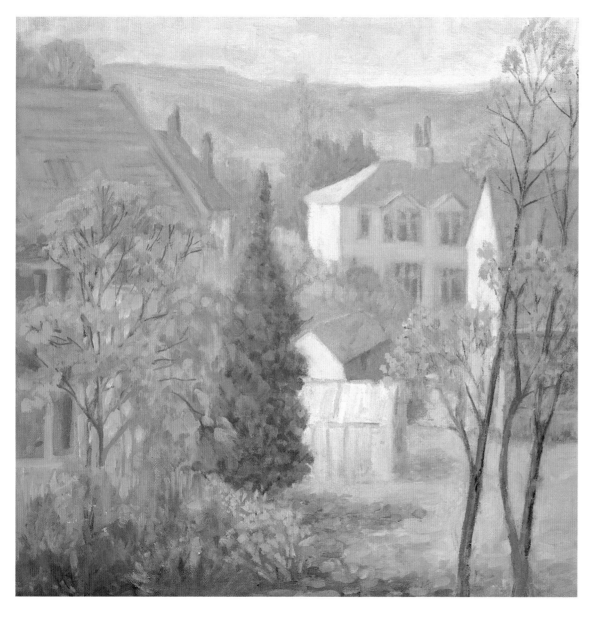

◄ VIEW FROM THE STUDIO
I painted this view from my studio
window in acrylics, using them like
oil paint, and working on canvas
board which increases the
resemblance to an oil painting.

Working freely with acrylics

Many years ago a tutor said to me: 'I love your studies but I hate the painting,' and I knew just what he meant! The problem is that anxiety to get it just right makes us timid and careful, and as we have discovered, *how* we work as well as how we think and feel is reflected in our paintings. The unforgiving nature of the watercolour medium only adds to our inhibitions. With acrylics, however, there is no limit to the number of changes and corrections that are possible, so we can throw anxiety and inhibitions to the winds.

Tips

If you have never used an opaque medium before, here are a few tips to help you.

- You will need a lot more paint than for watercolour, especially white to make colours paler, so squeeze out plenty – the quantity for each colour should be equivalent to one or two boiled sweets.

- Paint consistency is important: too thick is difficult to apply, too thin will not cover well.

- Opaque painters often blend colour on the painting surface, so if a colour looks too strong, work some white in before the first colour has time to dry.

- If an under-colour shows through, simply give it a second coat, or paint over with white and try again.

Project:
Rescuing a painting using acrylics

Take any unsuccessful flower painting and use acrylic paint to bring it to a more satisfactory conclusion. It may not be necessary to rework the entire picture. For example, if the flowers themselves are pleasing but the choice of background colour looks wrong, you need only rework the background. In any case, many acrylic painters start as you will be doing, i.e. with an under-painting of thin washes to establish the composition and colours; they then introduce white to the mixes and continue with opaque paint, working and reworking as often as is necessary.

My painting entitled *Lilies, Hostas and Hydrangeas* started out as a watercolour much like those in Lesson One, but the paint became a little muddy and the composition was unsatisfactory. In order to continue the work using acrylics, I taped the paper securely to a drawing board and set it vertically on the easel. I used the paint in a creamy consistency. Some of the original watercolour work can still be seen in the colours reflected in the tabletop, which is the only area not overpainted with acrylics.

▶ LILIES, HOSTAS AND HYDRANGEAS

Variation

Ideally I would like everyone to enjoy the creative freedom of a totally correctable medium, but if you are unable or unwilling to invest in acrylics, the project on this page could be reworked with a tube of white gouache paint to mix with your transparent watercolours. Although less dense, and translucent rather than completely opaque, some improvement, especially to overworked areas, is possible with gouache. White gouache on its own can also be used to recover lost highlights.

Working at an easel

This final project aims to let you experience the way of working described on page 97 which I call the PACK process. It involves a more physical approach to painting and is, I believe, so satisfying because it engages the whole person – body, mind and spirit. In my view, there is nothing to compare with the experience of standing at an easel and working on a vertical surface using long-handled brushes.

Project:

Painting, assessing, changing or keeping

Choose any subject, remembering that still life and flowers are easier than landscape. The point of the project is to make a continuous assessment of the work in progress, effecting such changes as seem called for as you go along. This does not mean making tentative dabs and hoping for the best, but keeping up an ongoing review leading to positive action. Trust and act on your intuition, and I promise you that with every such painting your aesthetic judgement and artistic ability will continue to blossom and grow, so that you will return to watercolours with improved confidence and skill.

◄ GARDEN IN THE WOODS
I usually paint directly onto the white watercolour paper, but in this example I scrubbed blues and dark greens all over the surface before drawing the outlines. Oil painters often work in this way so as to establish a particular colour mood, much as a pastellist might choose to work on dark paper.

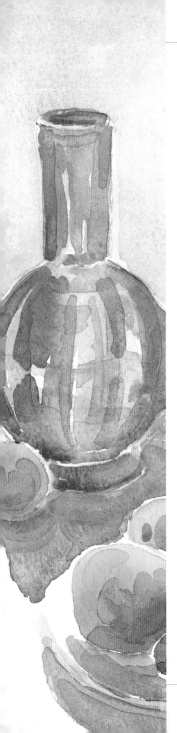

PROJECTS AND EXERCISES

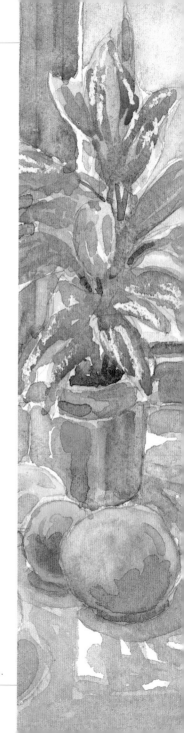

INDEX

Illustrations shown in *italic*